3/00

WHISTLER

Frances Spalding

Phaidon Press Limited
Regent's Wharf, All Saints Street, London N1 9PA

First published 1979
Second edition, revised and enlarged, 1994
Reprinted 1994, 1998
© Phaidon Press Limited 1994

A CIP catalogue record for this book is available from the
British Library

ISBN 0 7148 3186 7

Printed in Singapore

Cover illustrations:
Front: *Symphony in White No. 2: The Little White Girl*, 1864 (Plate 13)
Back: *Arrangement in Grey and Black No. 1: The Artist's Mother*, 1871
(Plate 29)

The publishers would like to thank all those museum authorities and
private owners who have kindly allowed works in their possession to
be reproduced.

Whistler

James McNeill Whistler's position in the history of British art is as paradoxical as his personality: flamboyant dandy and wit, he was also a serious craftsman, tirelessly dedicated to the perfection of his art. Having learned much from his French and English contemporaries, he nevertheless emerged as an isolated figure who attracted followers but established no leading style. Yet his influence was far-reaching. Largely owing to Whistler, England was slow to appreciate the French Impressionists. He derogated their 'screaming blues and violets and greens' and promoted instead a love of close, subtle tonal harmonies. His proud and independent nature can be felt in everything he did; even his smallest oil sketch or ink drawing betrays his refined sensibility. The writer Henry James, aware of the strain which Whistler's high and often unattainable standards imposed, told him: 'You have done more of the exquisite, not to have earned more despair, than anything else.' This search for perfection appears to have had spiritual significance for Whistler. Once, after attending a mediocre musical entertainment, Whistler turned to his companion, the artist Mortimer Menpes (1859–1938), and said: 'Let us cleanse ourselves, Menpes. Let us print an etching.'

A similar refined taste governed Whistler's appearance. His smartly tailored black frockcoats and jackets, white trousers and white waistcoats at first gave his devoted biographers, Elizabeth and Joseph Pennell, the impression of an old-fashioned American bartender. Small and immaculately dressed, to Menpes he always appeared 'dainty and sparkling'. On entering his hairdresser's in Regent Street, London, he immediately became the focus of attention: he directed the cutting of each lock, then dipped his head in a basin of water, wrapped his white forelock in a towel, shaking the rest of his black hair loose in natural curls. Once his hair was dry, he would demand a comb and, after the white forelock had been trained upwards like a feather, he would beam in the mirror and announce 'Menpes, amazing!' He would then seize his top hat and cane and leave the shop, spruce and resilient, the very picture of a dandy and renowned wit.

This extrovert image and his willingness to engage in lawsuits and warfare in the Press made Whistler a legend in his own lifetime. Fact became merged with fiction and the forces which motivated him as an artist became hidden behind a carefully cultivated, aggressive façade. He referred to himself as 'the butterfly' and used a monogram based on a butterfly motif as his signature. Although his art is the product of taste, he abhorred slickness and superficiality and would repeatedly rub down his canvases and begin again. His total *œuvre* is not large, yet it contains a number of masterpieces.

Whistler's career as a painter began when he came of age in 1855 and went to Paris. His father was a major and a resourceful railroad engineer, whose career ensured a cosmopolitan background for the

young James. Born in Lowell, Massachusetts, in 1834, he spent short spells at Stonington, Connecticut, and Springfield, Massachusetts, before moving with his family to St Petersburg, Russia, where Major Whistler was employed on the building of the St Petersburg to Moscow railroad. The artist's mother, Anna Mathilda McNeill, was a devout Christian who endeavoured to instill her pietistic beliefs in her children and whose abhorrence of ostentation left a marked effect on her son's taste. His admiration for her is indicated by his decision in early manhood to exchange his middle name 'Abbott' for her maiden name 'McNeill'.

A military and engineering background did not prevent Whistler's father from being sympathetic to the arts. In the evenings his daughter Deborah would play the harp or piano, or would sing. Major Whistler, on a holiday visit to England, commissioned a portrait of James from the artist Sir William Boxall (1800–79) and in Russia he showed an interest in the culture around him by visiting the imperial palaces and museums. The young Whistler accompanied his parents to the palace built by Catherine the Great at Tsarkoe Selo, which had a room decorated in the Chinese style. He would almost certainly have been taken to the Hermitage. But perhaps more memorable for the young boy living on the English quay, which directly overlooked the River Neva, were the frequent nocturnal firework displays that lit up the darkness with sudden showers of gold, a motif later to reappear in his 'Nocturnes'. (Plates 28, 32, 33, 36 and 39).

As a child Whistler had a passion for drawing. After a visit from the Scottish genre painter Sir William Allan (1782–1850), who admired the young boy's work, he was sent three times a week to the Imperial Academy of Fine Arts, where, in keeping with the academic tradition of art teaching, he drew from plaster casts of Antique sculpture. A sketchbook from this period (now at the University of Glasgow) shows that he was also copying religious and historical paintings. In 1846 his mother took him on more than one occasion to the Triennial Exhibition of the Academy in order to familiarize him with contemporary artists, retaining, however, her hope that his ultimate career would be that of an architect or engineer.

Fig. 1
The Coast Survey
1854–5. Etching,
14.3 x 26 cm.
British Museum, London

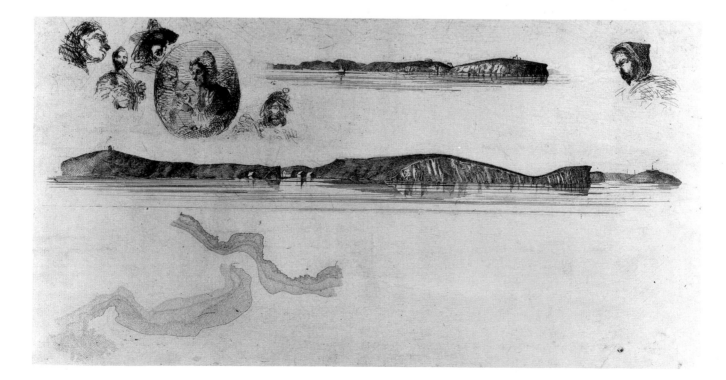

While living in St Petersburg the family made two visits to England. On the first, Deborah married the English surgeon, Francis Seymour Haden. On their second visit the young Whistler was left behind to complete his education, first at Portishead, near Bristol, and then in London. In 1849 Major Whistler died and his wife decided to return with her family to their homeland, settling at Pomfret, Connecticut, where James attended the local school until, in 1851, he was selected to go to West Point, the famous military academy on the west bank of the Hudson River and accessible only by boat.

West Point was isolated not only by its geographical position but also by its exclusiveness. Cadets were selected by congressmen and came mainly from distinguished families or from the southern aristocracy. Whistler's father had trained at West Point and this no doubt secured his entry. He was delighted to find himself 'very dandy in grey' and his years there were notable as much for his social success as for his dismal performance at all things military. The art master Robert W Weir (1803–89) encouraged his skill at drawing, while his wit compensated for his lack of skill in horsemanship. The officers at the academy were cordial, distinguished and elegant, setting a standard of behaviour which Whistler never forgot. Neither a soldier nor an engineer, Whistler nevertheless looked back on his three years at West Point with affection. The reason for his abrupt ejection from this institution was an abysmal failure in chemistry. 'Had silicon been a gas,' he later declared, 'I would have been a major-general.'

West Point was followed by a brief period of employment in the United States Geodetic and Coast Survey offices in Washington. Accounts of this period suggest that Whistler's social life in Washington was not conducive to the keeping of office hours. Not until he entered the etching department did he become absorbed in his work. He began work on a topographical view and within a couple of days had produced his first etching (Fig. 1). At intervals he broke away from the scientific precision needed for accurate topography and, in a style indebted to the illustrators of *Punch* and the *Illustrated London News*, sketched in the sky heads of characters drawn from his reading of Dickens, Scott, Dumas, Hugo and Thackeray.

Whistler's reading at this date was extensive and among the authors he favoured was Henry Murger, who in 1851 had published *Scenes from Bohemia*, later lengthened and entitled *Scenes of Bohemian Life* (Fig. 2). Whistler, who had learned French in St Petersburg, was so familiar with this book that, according to the Pennells, he knew passages of it by heart. The story centres on four young men, a painter, a writer, a painter-musician and a philosopher, who, convinced of their talents, regard themselves as an élite, outside the conventions and morality that bind normal society. They dress as they please, enjoy the company of pretty girls, despise discipline and cultivate a deliberate flippancy and language of their own. This behaviour is regarded by Murger as evidence of artistic ability. He also thought that a poverty-stricken but carefree lifestyle was a necessary stage in the life of an artist. Murger's tales first appeared in the magazine *Corsaire*. When published in book form he felt it necessary to add an introduction arguing the respectability of bohemianism: it is not, he says, peculiar to the present age but a stage through which many famous names (including Homer, Villon, Shakespeare and Molière) have passed. The book provided Whistler with a personal morality. Murger advocated 'a life of patience, of courage, in which one cannot fight unless clad in a strong armour of indifference...a charming and terrible life...on which one should not enter save in resigning oneself in advance to submit to the pitiless law *vae victis* [woe to the

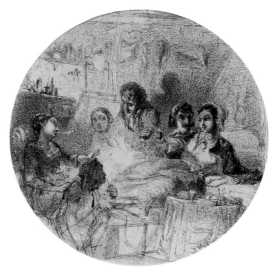

Fig. 2
Scene of
Bohemian Life
1857–8. Pen and ink,
diameter 23.8 cm.
Art Institute of Chicago,
Chicago, IL

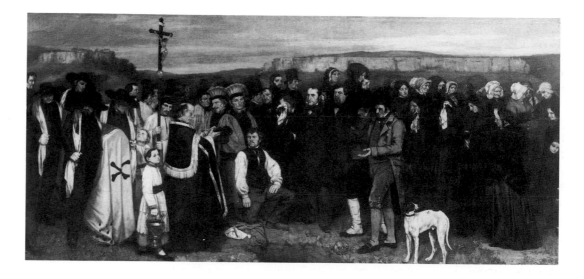

Fig. 3
GUSTAVE COURBET
Burial at Ornans
1848–50. Oil on canvas,
318.7 x 665.5 cm.
Musée d'Orsay, Paris

vanquished].' Warned of his subsequent isolation and attracted by the suggestion of separateness, Whistler set out to follow Murger's ideal. Geographical direction had been given earlier in the introduction. 'We will add', wrote Murger, 'that Bohemia only exists and is only possible in Paris.'

Whistler arrived in the artistic capital of Europe in 1855, in time to catch the tail end of the *Exposition universelle* which ran from May 15 to November 15 and attracted five million visitors. In the Fine Arts section the battle of styles, between Classicism and Romanticism, dominated public attention. Their chief exponents, Jean Auguste Dominique Ingres (1780–1867) and Eugène Delacroix (1798–1863), were still sufficiently influential to merit detailed attention in the poet Charles Baudelaire's review of the exhibition, which Whistler may have read. 'The Beautiful is always strange,' wrote Baudelaire; 'I mean that it always contains a touch of strangeness, of simple, unpremeditated and unconscious strangeness, and that it is this touch of strangeness that gives it its particular quality as Beauty.' Baudelaire's fastidious taste and his belief in the purity of art presage the attitude Whistler was later to adopt. The artist, who was to suffer much antagonism from the critics, would have fully supported Baudelaire's claim: 'Painting is an evocation, a magical operation...and when...the reanimated idea has stood forth and looked us in the face, we have no right...to discuss the magician's formulae of evocation.'

This and other reviews would have directed Whistler's attention to the pavilion of the artist Gustave Courbet (1819–77), erected at his own expense when the government, having accepted eleven of his paintings in the official exhibition, rejected two: *The Artist's Studio* (Musée d'Orsay, Paris) and *Burial at Ornans* (Fig. 3). These two masterpieces, monumental both in size and conception, were on view with Courbet's other paintings in the pavilion. The *Burial at Ornans*, with its long flat line of cliff pressing down on the frieze-like row of mourners, would have astonished Whistler with its abrupt, vigorous handling of paint and its lack of idealization in the portrayal of the figures. Courbet's shocking realism, linked in people's minds with socialism, was feared and distrusted; but he was too great an artist to be ignored. Baudelaire praised his 'positive solidity' and 'unabashed indelicacy', and Whistler found in Courbet's attitude to his subjects the initial inspiration for his own art.

In his choice of teacher, however, Whistler was surprisingly conventional. After a short period at the École Impériale et Spéciale de Dessin, he enrolled at the studio of Charles-Gabriel Gleyre

(1806–74), who trained his pupils for the *Prix de Rome* and other official competitions. Gleyre urged his students to make several sketches in quick succession in order to discover the most expressive composition. He taught them to analyse colour relationships and argued that ivory black was the 'universal harmonizer' and the basis of all tones. He also taught his students the practice of mixing their colours before starting to paint in order to leave them free to concentrate on form. All these lessons were important to Whistler. His choice of Gleyre indicates that he already sided with the Classical school, preferring a more restrained palette to the juicy crimsons and peacock blues of the Romantics; but his selection of teacher may also have been determined by the absence of tuition fees and by Gleyre's good reputation.

At Gleyre's, Whistler became part of the 'Paris Gang', a group of young English artists that included Edward Poynter (1836–1919), later President of the Royal Academy, Thomas Armstrong (1832–1911), Thomas Lamont (1826–98) and George du Maurier (1834–96). Eager to cultivate a Bohemian lifestyle, Whistler rapidly spent the quarterly installments of his annual $350 allowance, imitating the excesses enjoyed by Murger's heroes. He frequently had to sell his furniture or move into attic lodgings to survive and was disappointed when his friends did not follow suit. Like himself, they all had adequate funds, but they chose comfort rather than excess. Nor did they share his admiration for Courbet, finding his realism an aberration.

In the eyes of the public Courbet was the artist most closely associated with bohemianism; not only did his art reveal a shocking rejection of the conventional, but he frequented the Café Momus, the scene of Murger's café tales. Following Courbet, Whistler's earliest oil paintings are of the life he saw around him (Plate 2). Another of his models he picked up in Les Halles, a market in Paris (Fig. 19).

Early success for Whistler came not, however, through his painting but from his familiarity with the medium of etching. He had arrived in Paris to discover a revival of interest in this medium. In 1858 Whistler set out on a walking tour of Alsace-Lorraine and the Rhineland with the painter Ernest Delannoy, and he took with him a set of small copper plates. On these he etched scenes as he went, but when the two friends reached Cologne they ran out of money and the plates had to be left with their landlord in lieu of payment. Once these were returned to Whistler, he had them printed in Paris by Auguste Delâtre under the title *Twelve Etchings from Nature* and dedicated them to his brother-in-law Haden. Better-known as the 'French Set', these etchings, such as *The Kitchen* (Fig. 4), with their debt to seventeenth-century Dutch artists and to Jean-François Millet (1814–75), are surprisingly mature. Already they demonstrate Whistler's ability to regard the plate in terms of tone. Their suggestion of colour, as the critic Théodore Duret noted, makes them 'a painter's etchings' and they have none of the stiffness that the nature of the medium often encourages. Whistler stood at Delâtre's side while they were printed. His knowledge of the techniques of printmaking would have greatly increased through association with this man, whose shop was a rendezvous for printmakers and who had earlier been responsible for printing Charles Meryon's famous etchings of Paris, which represented the complex grandeur of the city in a way no artist had done before.

Praise of the 'French Set' encouraged Whistler to continue etching. Between 1858 and 1863 he produced 80 plates. In these it is possible to trace a gradual loosening of his technique, as his assurance increased, until his use of the medium comes close to the freedom of pen and ink. Two of the most attractive etchings produced in Paris are

Fig. 4
The Kitchen
1885. Etching,
22.5 x 15.6 cm.
British Museum, London

Fig. 5
Fumette Standing
1859. Drypoint,
34.5 x 21.5 cm.
British Museum, London

those of his mistresses. The first was Fumette (Fig. 5), a tempestuous woman who in a fit of pique tore up several of Whistler's drawings. After two years of misery, they parted and her place was taken by the elegant Finette (Fig. 6), who later made her way in the English music halls as a professional cancan dancer. Both etchings show Whistler's early preference for standing, full-length portraits and for the hint of informality.

During these student years in Paris, Whistler spent much time copying in the Louvre and on one of these visits he fell into conversation with a young French artist, Henri Fantin-Latour (1836–1904). Fantin-Latour had studied under Lecoq de Boisbaudran (1802–1897) at the École des Beaux-Arts, earning himself some success as a copyist. But his chief quality as an artist was his impeccable handling of tonal relationships. He and Whistler struck up an immediate friendship and that evening both went to the Café Molière, where Whistler met, among other artists, Alphonse Legros (1837–80), a precise, grave man with a hooked nose. Legros specialized in devotional subjects and church scenes. Like Fantin-Latour, he had trained under Lecoq de Boisbaudran and the two men taught Whistler Lecoq's belief that the training of the visual memory freed the artist from slavish imitation of nature. In conversation, the three men discovered their shared admiration for Courbet and for Dutch and Spanish seventeenth-century painting. Fantin-Latour and Legros admired Whistler's 'French Set', which he had brought with him to show them, and before long it was agreed that their sympathies and interests should unite them in a *Société de trois* (Society of Three).

Shortly after meeting Fantin-Latour, Whistler set to work on his first major painting, *At the Piano* (Plate 3). It is unlikely that a man who had not responded deeply to music would have painted this subject. Music had been a part of Whistler's childhood and at the Hadens' house in Sloane Street he continued to listen to his sister play and sing. He enjoyed music at the home of the Greaves family, encouraged hurdy-gurdy players to perform in the garden outside his house, and painted a vivid portrait of the violinist, Pablo Sarasate. Aware of a profound correspondence between his artistic aims and his experience of music, he later entitled his paintings, 'Symphonies', 'Nocturnes', 'Arrangements' and 'Harmonies', wanting to create in his art an experience as disinterested and pure as that offered by music.

At the Piano is Whistler's first masterpiece. It has a solidity, craftsmanship and resonance that make it one of his most satisfying works, yet it was rejected in 1859 by the jury of the Salon, an official French exhibition of paintings, held annually. An exceptionally large number of works were thrown out that year and the Salon itself, as Baudelaire noted, was dominated by mediocrity. Whistler's painting was instead exhibited in the studio of François Bonvin (1817–87), where it was admired by Courbet. Failure to get his work accepted by the Salon, combined with the success of his etching, contributed to Whistler's decision to move to England in 1859. *At the Piano* marks the end of his student years and the onset of artistic independence.

In London, Whistler's initial base was the Hadens' four-storied house, 62 Sloane Street. The lifestyle he enjoyed there was one of elegant wealth; champagne frequently accompanied the five-course meals and the area was sufficiently close to Mayfair to be considered fashionable but not ostentatious. He enjoyed a close sympathy with his half-sister, and his relations with Haden also began harmoniously. As Whistler put it, Haden was 'glorying in the artist who let the surgery business slide', having recently renewed his interest in etching and the two men went on etching trips together out to the

Fig. 6
Finette
1859. Drypoint,
28.9 x 20 cm.
British Museum, London

fields west of London. Delighted with his new surroundings and the patronage he was beginning to enjoy, Whistler wrote to Fantin-Latour and Legros urging them to join him in London.

The artist whom Whistler seems to have had very much in mind during 1859 was Charles Meryon. At the Salon that year Meryon's etchings of Paris were highly praised by Baudelaire, who wrote, 'I have rarely seen the natural solemnity of an immense city more poetically reproduced.' According to the Pennells, on a brief visit to Paris in the winter of 1859 Whistler attempted to 'rival Meryon' by etching a view of the city from the Galerie d'Apollon in the Louvre, but gave it up before the plate was completed. One of Meryon's prints

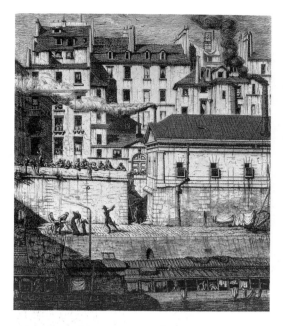

Fig. 7
CHARLES MERYON
The Morgue
c1850-4. Etching,
21.3 x 18.7 cm.
British Museum, London

Fig. 8 Opposite
Rotherhithe
1860. Etching,
27.3 x 19.7 cm.
British Museum, London

which Whistler would have known well was *The Morgue* (Fig. 7). A copy inscribed with a dedication from Meryon belonged to Félix Bracquemond (1833–1914), the etcher, whom Whistler had met through Fantin-Latour. Haden also owned two copies of this print, as well as two preparatory drawings for it. Whistler would have admired its planar simplification and the suggestion of atmosphere. He may also have been intrigued by the subject – in the lower left two men are carrying to the morgue the corpse of a drowned victim retrieved from the Seine. There was in London one area where men made a living by searching the Thames for whatever flotsam, human or otherwise, the tide which flowed from Southwark Bridge to Millwall threw up. This was Wapping and Rotherhithe, the scene of Whistler's next set of etchings.

Attracted to this area partly by its complete contrast with the safe, secure world of Sloane Street, Whistler may also have realized that the view across the river would give him, as it gave Meryon, the necessary distance from which to observe the complex conglomeration of city architecture. Soon after settling in London Whistler had taken rooms with George du Maurier in Newman Street, Bloomsbury, but he was frequently absent from there, staying instead at the Angel Inn in Cherry Gardens, Rotherhithe. Du Maurier told his mother that Whistler was 'working hard and in secret down in Rotherhithe, among a beastly set of cads and every possible annoyance and misery'. If lacking the more conventional comforts, the area was rich in visual interest: the river scene presented a confused forest of masts, flags and rigging, set against tall chimneys that belched forth black smoke. Amidst it all, mixing happily with tough-fisted bargees, the dandified American was at work on his second masterpiece, *Wapping* (Plate 6) and on a series of etchings known as the 'Thames Set'.

The 'Thames Set' differs from the 'French Set' in a number of ways. The views represented are more spacious, the compositions more subtly designed. The use of hatching to create texture and tone is more controlled, and as a result Whistler achieves richer effects by fewer means. His use of line takes on a new freedom, encouraged perhaps by the sweeping lines of the rigging and masts that he drew. In *Rotherhithe* (Fig. 8) he varies his treatment for the delineation of flesh, bricks and masts, decreases the darks in the far distance and suggests wispy clouds by the slightest of scratches. It is said that a brick fell while he was at work on this plate, causing him to start and scratch a line down through the sky. He claimed each plate in the 'Thames Set' took him three weeks to produce, but he probably worked on more than one at a time. For the initial printing, Delâtre was brought over from Paris. When exhibited in Paris in 1862, they caught the attention of Baudelaire, who wrote of 'wonderful tangles of rigging, yard-arms and rope; farragos of fog, furnaces and corkscrews of smoke; the profound and intricate poetry of a vast capital'.

Whistler's fine colour sense is evident in his *The Thames in Ice* (Plate 4), painted on Christmas day 1860. His obsession with rivers and the sea reflects an aspect of all the places in which he lived: Stonington looks out over the Atlantic Ocean; Springfield lies on a curve of the Connecticut River; St Petersburg is dominated by the Neva; West Point is on the Hudson River; and in London, Whistler was attracted immediately to the Thames.

Whistler's life at this time was by no means confined to dockland. He enjoyed the patronage of the Ionides family, wealthy Greek art collectors, and frequently dined at their house in Tulse Hill. Concurrently with the 'Thames Set', he painted *Harmony in Green and Rose: The Music Room* (Plate 5), a scene far removed from the harsh

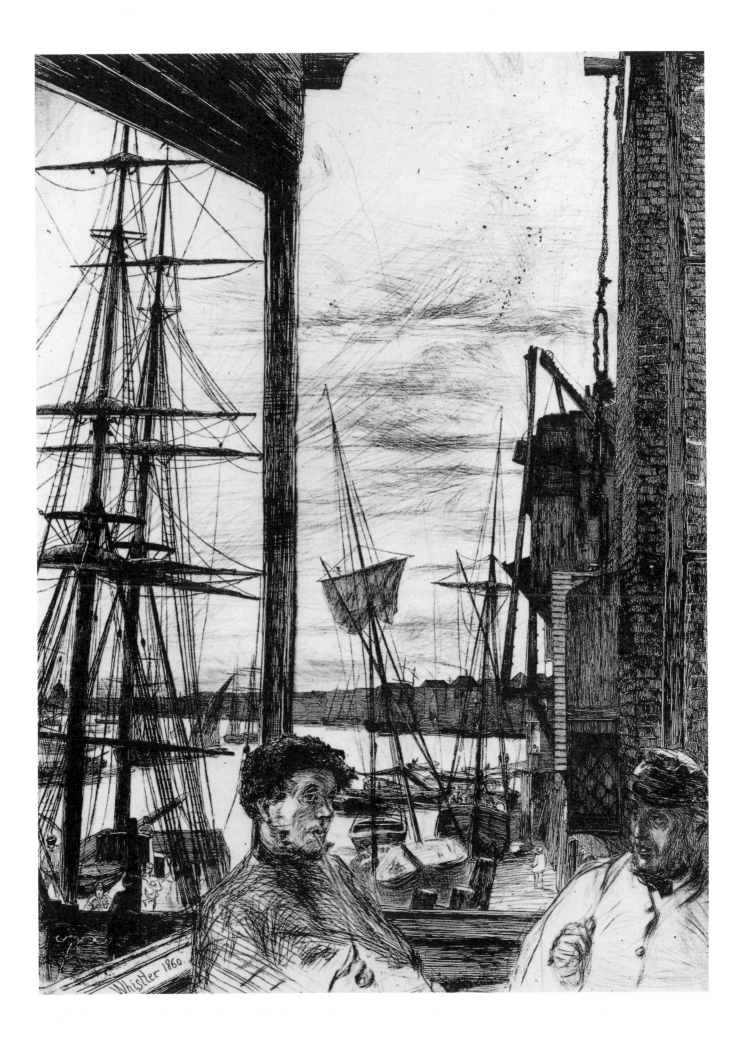

trappings of Rotherhithe.

A cosmopolitan background had given Whistler a certain love of travel and, although based in London until 1892, he made frequent visits abroad. In the summer of 1861 he went on a painting trip to Brittany. The following autumn he set out for Spain, intending to see the paintings by the Spanish painter Diego Velázquez (1599–1660) at the Prado in Madrid. He reached Fuenterrabia, a fortified town just across the border between France and Spain, but was discouraged by his lack of knowledge of the Spanish language and the difficulties encountered when he tried to paint out of doors. Jo, who was with him, was not well, and without going any further he turned his back on the Prado and returned home.

After the Brittany trip, Whistler took a studio that winter in the boulevard des Batignolles in Paris, where he began work on *Symphony in White No. 1: The White Girl* (Plate 7). The model was his mistress, Jo, whose character seems to have been very different from that suggested by the painting. Red-haired and Irish, for a few years she managed Whistler's affairs, keeping house for him and assisting him with the sale of his work. To give herself respectability, she called herself Mrs Abbott and was known by that name in Bond Street; her drunken father also referred to Whistler as 'me son-in-law'. Whistler was fascinated by her red hair, and when he first introduced Jo to Courbet he pulled down her long hair to give it full effect. Courbet also responded to her beauty and painted her combing her hair in *The Beautiful Irish Girl*, of which four versions exist, one in the Metropolitan Museum of Art in New York. Later, in 1866, she posed as one of the two nude women in Courbet's *Sleepers* (Petit Palais, Paris), a fact that may have contributed to Whistler's decision to break with her.

In *Symphony in White No. 1: The White Girl* Whistler came closest in mood to Pre-Raphaelitism. He had become known to his English colleagues after the success of his *At the Piano* in 1860; the painter Sir John Everett Millais (1829–96) had praised it as 'the finest piece of colour that has been on the walls of the Royal Academy for years'. But not until 1863, when he moved to 7 Lindsey Row, Chelsea, (now Cheyne Walk) in close proximity to Tudor House where the Pre-Raphaelite painter Dante Gabriel Rossetti (1828–82) lived, did Whistler begin to enjoy friendship with this group. That year Du Maurier informed Armstrong, 'Jimmy and the Rossetti lot, i.e. [the poet] Swinburne, [the novelist] George Meredith and [the painter] Sandys, are as thick as thieves.' If *Symphony in White No. 1: The White Girl* is as moody and enigmatic as certain paintings by Millais, Whistler's drypoint, *Weary* (Fig. 9), shares Rossetti's interest in languorous, sensuous women and in sleep which was thought to suggest spiritual remoteness. Rossetti and Sandys had an obsession with hair, and here Whistler lets it fly out, creating an aureole around the sitter's head. The whip-like movement of the needle over the plate suggests that he was becoming irritated by the limitations of the medium and during the next six years he hardly touched etching at all.

The move to Chelsea also brought Whistler the friendship of the Greaves family who lived at one end of Lindsey Row. The father built and rented boats and had earlier rowed the painter J M W Turner (1775–1851) across the river on fine days to the fields at Battersea (now Battersea Park). At 4 Lindsey Row until 1854 had lived the romantic painter, John Martin (1789–1854), who instructed Greaves to knock on his door at night whenever a full moon and clouds were making fine sky effects. One of Greaves's sons, Walter, at the age of sixteen painted a large, lively work, *Hammersmith Bridge on*

Fig. 9
Weary
1863. Drypoint,
19.7 x 138 cm.
British Museum, London

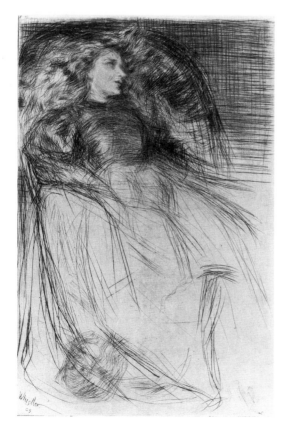

Boat Race Day (Tate Gallery, London) in a naïve style. His brother Henry also painted, and these two young men now attached themselves to Whistler; he taught them to paint and they taught him to row with the 'Waterman's jerk' and introduced him to the nearby Cremorne Gardens (Fig. 10). Walter Greaves was the more talented of the two, capable of affectionate care in the construction of complex compositions and in his use of subtle colouring. Over the next 15 years he became Whistler's most devoted disciple, not only submerging his personal style in imitation of his art, but also adopting his mannerisms and dress. This dedication brought him little reward. Towards the end of his life, his top hat battered and worn, he haunted the bookshops near the British Museum, offering sketches of his beloved Chelsea in return for books, and eventually died in a poorhouse in 1930.

Whistler's association with the Greaves family deepened his knowledge and love of Chelsea and the Thames. Before the Embankment was built in 1871, putting a barrier between the city and the river along which thundering traffic now passes, the river bank at Chelsea was little more than a picturesque path, an area much quieter than London's docklands and offering more contemplative subjects. In the company of the Greaves brothers, Whistler often spent all night on the river making brief notes in chalk on brown paper in preparation for his 'Nocturnes'. On occasion they would rise at five o'clock in the morning and row up to Putney to breakfast with Rossetti's friend, Charles Augustus Howell.

The change in Whistler's attitude to the river can be seen by comparing *The Last of Old Westminster* (Plate 8) with *Brown and Silver: Old Battersea Bridge* (Plate 9). The more distilled mood of the latter is partly indebted to Whistler's growing interest in Japanese prints. These taught him how to employ perspectival effects without destroying the tension created by the design on the picture surface.

It is almost certain that Whistler would have seen examples of Japanese prints during his student years in Paris. Through Fantin-Latour he had met Félix Bracquemond, who owned a copy of *Mangwa* by the Japanese artist Katsushika Hokusai (1760–1849) and showed it at every opportunity. However, Whistler's interest in this art form only began to develop around 1862–3. By 1864 he had become a regular customer of Madame de Soye's shop in Paris, 'La Porte chinoise', and his letters to Fantin-Latour contain frequent references to this shop and to Japanese art. He developed a passion for oriental blue and white china and vied with Rossetti for choice acquisitions. So great was Whistler's love of blue and white that on hearing of the massacre of the Ministers in Peking in 1900, he declared: 'Well, it is the Chinese way of doing things and there is nothing to redress. Better to lose whole armies of Europeans than harm one blue pot!'

Meanwhile Whistler's personal life was far from secure. His relationship with his brother-in-law had deteriorated beyond repair owing to Haden's somewhat patronizing manner; and, though Haden had dined happily at Lindsey Row, he forbade his wife to visit her brother because of Jo's permanent residence in the house. This embargo continued even after Whistler's mother arrived in London in 1863, after which Jo was obliged to lodge elsewhere. Jo herself was causing concern. Acting the *grande dame*, she insisted on wearing expensive clothes and was observed by Du Maurier 'got up like a Duchess'. She may also have aroused Whistler's jealousy on his visit to Trouville, France, in 1865 by flirting with Courbet. Personal tensions at this time were mixed with doubts about his artistic progress; Whistler wrote bitterly to Fantin-Latour about the slowness, hardness and uncertainty of his work, complaining that he produced little

Fig. 10
HENRY AND WALTER GREAVES
Cremorne Gardens, with a portrait of Whistler
1870s. Pencil and grey wash, 48.9 x 61.6 cm.
Private collection

because he rubbed so much out. His self-confidence was further undermined by the arrival in London of his brother who had played an important part as a surgeon in the Southern Army in the American Civil War, while Whistler, trained at West Point, patriotic and devoted to the South, had remained safely in England.

In 1866 Whistler was approached by some men from West Point and asked to take part in the war being fought by Chile and Peru against Spain and surprisingly he agreed. He had no commitment to Chile, nor was the war one that raised important issues of social rights: the reason for his sudden departure was probably the number of problems besetting him in London. On arrival at Valparaiso in Chile he saw little more than a skirmish when the Spanish fleet opened fire on the town and his immediate response was to ride out of the town as fast as his horse could carry him.

Whistler's trip to Valparaiso did not banish his unease. On board ship during his return home, he attacked a black man, kicking him downstairs, and was confined to his cabin for the rest of the trip. This aggressiveness broke out again soon after his reappearance in London when he quarrelled with Legros and floored him with a hard blow in the face. In Paris that same year, he quarrelled so violently with Haden that he knocked him through a plate-glass window. At the same time he was becoming increasingly conscious of his personal style, taking great care over the cut of his clothes and moving into a more elegant house in Lindsey Row, no. 2, where he tacked purple Japanese fans on to the blue walls and ceiling of his dining-room. By 1869 Jo had been replaced by Louisa Fanny Hanson, about whom little is known except that the following year she bore Whistler a son (christened Charles James Whistler Hanson) and then disappeared, leaving the son to be adopted and raised by Jo.

This period of malaise coincides with an artistic crisis in Whistler's career. On his return from South America, he had written to Fantin-Latour denouncing the influence of Courbet. He regretted that he had been so swayed by the cult of Realism, which he felt had prevented him from gaining a thorough grounding in art. 'If only I had been a pupil of Ingres,' he complained, drawing attention to his lack of skill in drawing and to his desire for a more classical, timeless style than that which Realism produced.

Whistler's turning to classicism was encouraged by his friendship with the 24 year-old painter Albert Moore (1841–93) whom he met in 1865. Moore's interest in classical art, begun in Rome, had led him to make a careful study of the British Museum's Elgin Marbles, especially their graceful, flowing draperies. In 1864 and 1865 he exhibited paintings of classically-draped women at the Royal Academy. Both paintings are lost, but the second, *The Marble Seat*, was entirely without literary or allegorical content. Whistler, impressed by Moore's purely decorative aims, wrote to Fantin-Latour in August 1865 suggesting that Moore should replace Legros in their *Société de trois*. The same letter contains a sketch of a painting on which he was at work, the *Symphony in White No. 3* (Plate 21), not completed until after his return from Valparaiso.

Symphony in White No. 3 was followed by two years of uncertainty. Whistler exhibited nothing in 1868 or 1869 and during this time was occupied with his 'Six Projects' (Plates 22 and 24), a series of figure paintings in which he attempted to combine Japanese and Greek influences. Only one ever came near completion, *Three Figures, Pink and Grey* (Tate Gallery, London) and that he later wanted to destroy. The remaining oil sketches were initially begun as a decorative series for his patron, Frederick Leyland. Whistler was sharing rooms with

the architect Frederick Jameson at the time and Jameson recalled that Whistler was beset by doubts. The cocksure dandy was 'painfully aware of his defects' and no sooner was a large portion of a canvas finished than it was 'shaved down to the bedrock mercilessly'. The oil sketches reveal Whistler's desire for directness and simplicity in the handling of paint, and the decorative subject, of elegant women posed on the seashore against a high horizon, has no other content than beauty – of line, colour, design and pose.

Behind these charming but slightly vacuous paintings lies the influence of Swinburne (Fig. 11). In 1866 the poet, in an article on William Blake (1757–1827), had roundly declared that art was divorced from morality and that an ethical message was unnecessary in art. Two years later, in an essay 'Some Pictures of 1868', he found in the work of Moore and Whistler an illustration of his belief in 'art for art's sake'. He praised Whistler's 'Six Projects', which he must have seen in his studio, and, appreciating the analogy with music that both Moore and Whistler were making in their art, wrote of Moore's painting: 'The melody of colour, the symphony of form is complete.' If Swinburne's essay reflects to some extent his conversations with Whistler, the poet's emphasis on the worship of beauty gave a coherence to Whistler's aesthetic, which had previously been put together intuitively. 'The worship of beauty,' wrote Swinburne, 'though beauty be itself transformed and incarnate in shapes diverse without end, must be simple and absolute.'

A simple schematic division of the picture surface is found in *Arrangement in Grey and Black No.1: The Artist's Mother* (Plate 29). Here Whistler returns to the domestic subject and planar severity of *At the Piano*, employing a subtle range of low tones and a dominant black. The complete change of mood, from the artificial flamboyance of the 'Six Projects' to the quiet sincerity of the portrait of his mother, must partly have been determined by the sitter's character. Quiet, reserved, pious and shy, Anna Mathilda's friends spoke of her as 'one of the saints upon earth', and in company she would seek out the corners of rooms and sit quietly sewing. Her inner quietness enabled her to sit patiently while her nervous son rubbed out one attempt after another in his search for perfection.

Thomas Carlyle, the Scottish essayist and historian, known as the 'Sage of Chelsea', when taken to see this portrait, declared it had 'massive originality'. He agreed to sit for his own portrait in a similar pose and the result, entitled *Arrangement in Grey and Black No. 2: Portrait of Thomas Carlyle* (Plate 31), has obvious similarities. Technically, the portrait of Carlyle is looser in execution than the portrait of Whistler's mother, the linearity more pronounced, the accoutrements positioned to give more movement to the composition, and the mood, though still introspective, is less introverted. Whistler was after the same studied elegance that he admired in *Man with the Glove* in the Louvre by Titian (*c*1487–1576), as well as the sombre tonalities and limpid, flowing execution that he admired in Velázquez's paintings. This latter quality he had more opportunity to pursue in his *Harmony in Grey and Green: Miss Cicely Alexander* (Plate 34), painted at the same time as the portrait of Carlyle. Of the three portraits, this has the greatest openness of touch, the paint being freely manipulated in the creation of the dress, the matting and the floating feather of her hat, the grey circle of which gives the right note of weight to the lower part of the composition and positions the figure. Whistler himself designed the dress and specified how it should be laundered.

Concurrently with these portraits Whistler produced a series of

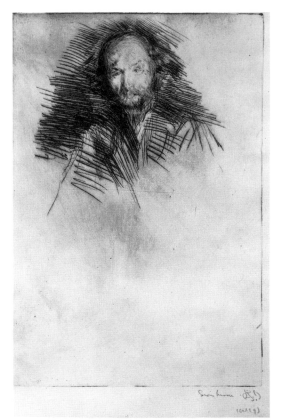

Fig. 11
Swinburne
1870s. Drypoint,
27.6 x 18.6 cm.
Freer Gallery of Art,
Washington DC

'Nocturnes' – paintings of the Thames at night. The view across the river from Lindsey Row, and that on the same side a little below Chelsea, was a complex pile of warehouses, factories and smoking chimneys, an industrial eyesore to most, but to Whistler a subject that he had already used in the far distance in *The Thames in Ice* (Plate 4) and in *Variations in Flesh Colour and Green: The Balcony* (Plate 18). He was attracted to dusk and night because the absence of light caused forms to be simplified and colours to be lost in one general hue. He had first painted a 'Nocturne' at Valparaiso, but in the early 1870s he developed a system and a formula which he could vary with subtle effect. He would mix his colours beforehand, using a lot of medium, until he had, as he called it, a 'sauce'. Then, on a canvas often prepared with a red ground to force up the blues and suggest darkness behind, he would pour on the fluid paint, often painting on the floor to prevent the paint running off, and, with long strokes of the brush pulled from one side to the other, would create the sky, buildings and river, subtly altering the tones where necessary and blending them with the utmost skill. The general scene would then be punctuated with a barge or a small figure, or the lights on the far bank would create with their reflections stabbing verticals in the horizontal wash of colour.

Whistler's 'Nocturnes' evoke a mood of tenderness and poetry similar to that expressed in 1885 in his *Ten O'Clock Lecture*, a mood distilled from his experience of long nights spent on the river in the company of the Greaves brothers:

> And when the evening mist clothes the riverside with poetry, as with a veil, and the poor buildings lose themselves in the dim sky, and the tall chimneys become campanili, and the warehouses are palaces in the night, and the whole city hangs in the heavens, and fairyland is before us.

One of his most famous works in this series is *Nocturne: Blue and Gold – Old Battersea Bridge* (Plate 33). The silvery light explains why Whistler originally called these paintings 'Moonlights'. His patron Frederick Leyland, an enthusiastic pianist and probably familiar with Chopin's music, suggested the term 'Nocturne'. Whistler replied, 'I can't thank you too much for the name Nocturne as the title for my Moonlights. You have no idea what an irritation it proves to the critics, and consequent pleasure to me; besides it is really so charming, and does so poetically say all I want to say and no more than I wish.'

Whistler's notion that his 'Nocturnes' would anger the critics was not mistaken. The critic John Ruskin, when faced with *Nocturne in Black and Gold: The Falling Rocket* (Plate 36) and other night scenes at the opening exhibition of the Grosvenor Gallery in 1877, was so outraged that he broke out in print with harsh invective: 'I have seen and heard much of Cockney impudence before now; but never expected to hear a coxcomb ask two hundred guineas for flinging a pot of paint in the public's face.' Whistler showed this passage to a friend who suggested that it constituted libel and the result was the famous Whistler v. Ruskin trial, which Whistler, largely through his wit and sense of timing, won. The battle involved two opposing artistic philosophies; whereas for Ruskin art was inextricably bound up with ethics and could and should act as a moral directive, Whistler believed that art stood apart from practical life, offering a pure experience untouched by moral necessity. 'Art', said Whistler, 'should be independent of all clap-trap, should stand alone, and appeal to the artistic sense of eye or ear, without confounding this with emotions

entirely foreign to it, as devotion, pity, love, patriotism and the like.'

Whistler had to wait over a year for this trial to take place and in the meantime he lost the support of his leading patron, Frederick Leyland, to whom he had first been introduced by Rossetti. Leyland was a self-made Liverpool shipowner, wealthy and influential, who found collecting one outlet for those energies not satisfied by his business interests. On his return home at night he would go straight up to his room and furiously practise scales on the piano. Tall, lean, bearded, he was, Whistler thought, 'portentously solemn'. He generously patronized contemporary artists, including a number of Whistler's friends, and for this earned the nickname the 'Liverpool Medici'. Since the autumn of 1869 Whistler had been a regular visitor at Leyland's manor house, Speke Hall, eight miles from Liverpool, where his interest in etching revived and he executed plates of Liverpool docks and of Leyland's family (Fig. 12). Leyland's three daughters and son delighted in Whistler, as did his wife, who enjoyed with the artist an *amitié amoureuse*. Full-length portraits of both husband and wife were commissioned and work continued on these in both Liverpool and London. For *Symphony in Flesh Colour and Pink: Portrait of Mrs Frances Leyland* (Plate 26) Whistler again designed the dress and seized on a pose, adopted unconsciously by the sitter while talking, that struck just the right note of negligent elegance. But the good relations that Whistler enjoyed with his forbearing patron and his attractive wife turned to bitter hatred over the decoration of the famous Peacock Room (Plate 38).

The Peacock Room was the dining-room at 49 Princes Gate, Leyland's London home. At first, he brought in the architect Thomas Jeckyll to redesign the room in a way that would house his collection of blue and white china. Jeckyll covered the walls with leather imprinted with red flowers and constructed an elaborate system of shelving, suitably Japanese in style, to house the china. Overhead hung an incongruous Jacobean ceiling with large gaslights affixed to its pendants. 'To speak most tenderly,' wrote the architect E W Godwin, 'it was at the best a trifle mixed.' Jeckyll then hesitated as to which colours he should choose for the doors and window frames and Mrs Leyland wrote to Whistler for advice. Whistler's main criticism was that the red border in the carpet and the red flowers in the leather did not harmonize with his *La Princesse du pays de la porcelaine* (Plate 12), one of his oriental subjects produced during the early 1860s, which hung in pride of place over the mantelpiece. He asked permission to retouch the leather and make other small alterations.

Finding the retouching of the leather inadequate, Whistler, aided by the Greaves brothers, began to repaint the entire room a deep blue. He had earlier chosen blue for his own dining-room at Lindsey Row, but the final effect of the Peacock Room was very different from the restrained, uncluttered interiors he normally favoured – the product of his New England background, his admiration for Japanese art and his friendship with the 'aesthetic' architect, E W Godwin. Instead of austerity and restraint, the Peacock Room glitters and sparkles with gold, the shelves being gilt with gold leaf and the shutters of the windows decorated with designs of peacocks, their elaborate feathers showering out like a flood of gold coins. As if this were not enough, Whistler picked up the motif of the eye and breast feather of the peacock in decorative waves around the walls. 'I just painted it as I went on', he later said of the room, 'without design or sketch.' As it grew in importance for him, he moved into 49 Princes Gate and worked from dawn to dusk. When it approached completion he had a pamphlet printed on the room and sent it to the Press, at the same

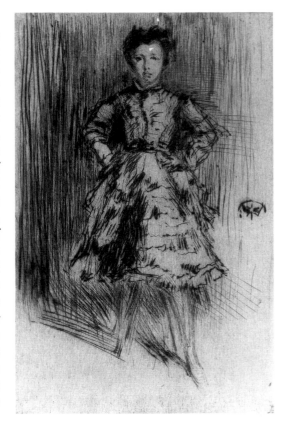

Fig. 12
Elinor Leyland
1873. Drypoint,
21.3 x 14 cm.
British Museum, London

time sending out cards of admission and leaving others at the shop Liberty's to interest the public. Convinced that he had produced the most beautiful room in all London, Whistler, in his arrogance, was led to abuse his patron. On a visit to the house, Mrs Leyland overheard him say, 'Well, what can you expect from a *parvenu*?' He was ordered out of the house, but allowed back to put some finishing touches to the shutters.

Leyland, insulted by Whistler's behaviour and furious that his private home had been turned into a public gallery, was then presented with a bill for 2,000 guineas. Considering Whistler already owed Leyland £1,000 in advances for undelivered paintings, the £1,000 cheque he now received was not ungenerous; but only tradesmen were paid in pounds, not guineas, and Whistler was infuriated by the absence of shillings. A long and violent quarrel ensued in which Leyland wrote Whistler one of the most damning letters he ever received, pointing to his inability to complete any serious work and to the degradation of his character: 'The fact is your vanity has completely blinded you to all the usages of civilized life, and your swaggering self-assertion has made you an unbearable nuisance to everyone who comes in contact with you.'

The loss of Leyland as a patron and the effect of Ruskin's harsh criticism left Whistler in an unhealthy financial position. This did not prevent him from commissioning Godwin to build him the White House in Tite Street, Chelsea, which was completed in the autumn of 1878. The Whistler v. Ruskin trial was heard on 25 and 26 November of that year and, though victorious, Whistler was awarded only a farthing in damages, and faced £1,000 in costs. In May the following year he was declared bankrupt and in September the White House was sold and its contents dispersed, several of Whistler's paintings having already been deposited with the printers Messrs Graves as security for loans. Whistler, living a hand-to-mouth existence, was even forced to part with *Arrangement in Grey and Black No. 1: The Artist's Mother*, which with two 'Nocturnes' fetched a loan of £100. Not surprisingly, at a meeting of his creditors, the man who lived with his nerves always seething beneath a veneer of refinement lost control and broke out in a tirade against British millionaires.

A trip to Venice provided the antidote to Whistler's dire condition. Plans to visit this city and produce a new set of etchings had previously been made in 1876, but had been postponed because of the Peacock Room. Now the Fine Art Society provided him with £150 for a three-month visit, in return for which they took the option on buying his plates and printing them in an edition of 100 impressions on his return. He left for Venice early in September 1879 and was followed a month later by his new mistress Maud Franklin, a slim redhead who had stayed with him throughout his worst days of poverty. He settled first at the Palazzo Rezzonico, moved to other lodgings and finally settled at the Casa Jankowitz, which housed a large party of American art students. At first he had difficulty settling down to work, but gradually his confidence returned. Before long he was established at the centre of the English-speaking community and could be found at night in the Piazza San Marco 'praising France, abusing England, and thoroughly enjoying Italy'.

Whistler stayed not three but fourteen months in Venice and during that time produced four oils, many etchings and almost 100 pastels. Many of the latter are merely coloured drawings, charming but slight; they could not have taken more than a few hours to produce. In others the pastel is boldly rubbed into position to suggest sunsets and other atmospheric effects. All were executed on brown paper (which he

Fig. 13
The Doorway, Venice
*c*1880. Etching and drypoint, 29.5 x 20.3 cm.
Hunterian Museum and Art Gallery, University of Glasgow, Glasgow

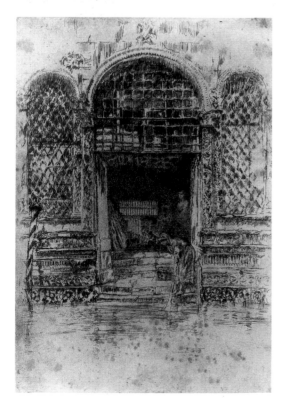

found in a Venetian warehouse) to give a warm background tone and they sold well on his return to London. More remarkable are his etchings, in which he adopted an entirely new 'impressionistic' style. He used a lighter, more broken touch than in the 'Thames Set', well-suited to the transient magic of Venice. Instead of taking the composition to the edges of the plate, he adopted a more allusive approach, often leaving areas incomplete or merely suggested. He employed a variety of techniques, mixing drypoint with etching and frequently leaving a slight film of ink on the plate to suggest water or to enrich the tone (Fig. 13). Several of the plates were extensively reworked in London, growing richer and more elaborate with every new state.

When exhibited at the Fine Art Society in 1880, his first set of Venetian etchings was criticized for being unrepresentative of the city. Aware of an overwhelming precedence for the more popular views, Whistler deliberately investigated the poorer parts of Venice, the narrow passageways inhabited by light and shade. This series, therefore, reflects the return of his interest in genre subjects as well as his delight in the tapestry-like effect of Venice's crumbling walls and elegant façades.

By the end of his stay in Venice, Whistler, confident again of future success, was anxious to return home. 'I am bored to death after a certain time away from Piccadilly,' he wrote to his sister-in-law, 'I pine for Pall Mall and I long for a hansom!' Accounts of his stay in Venice leave the impression of forced levity. He never let the art students among whom he lived forget his importance and developed an annoying habit of referring to himself in the third person: 'Whistler must get back into the world again.' His departure was witnessed with some relief.

Whistler's reappearance in London did not go unnoticed: he entered the Fine Art Society with a shoulder-high cane in one hand and a Pomeranian dog on the end of a long ribbon in the other. He looked at the prints on the wall (some probably by Haden, who was present) and said, 'Dear me! Dear me! Still the same sad old work!' He began moving in literary circles and for a while was closely associated with Oscar Wilde (Fig. 14), the poet and publicist of the Aesthetic movement, but became irritated by Wilde's dress and by his tendency to adopt the wit and ideas of others. 'What has Oscar in common with us artists,' he asked, 'except that he dines with us, and steals the plums from our plates to stuff the puddings that he goes and peddles in the provinces?'

Whistler had returned with the intention of conquering society and painting 'all the fashionables'. He wanted to give his sitters an impersonal elegance beyond style or fashion, but his reputation for fastidiousness meant that his sitters needed good health to endure the numerous sittings, and personal courage to withstand his wit. He established himself at 13 Tite Street, Chelsea, and in his pale yellow dining-room held his Sunday breakfasts. Yellow flowers placed in blue vases made a harmony of blue and yellow and in the centre of the table goldfish swam in a large Japanese bowl. Stylish entertainment, however, attracted only a few sitters; his chief patronage in the 1880s came from Americans and it was not until the following decade that he was in demand as a portrait painter.

The formula adopted for his full-length portraits had been established in the 1870s. His painting of Rosa Corder (Plate 37) is an example of the noble elegance and proud sense of individuality which he attained in these portraits, uncluttered by any of the standard accoutrements used to suggest the sitter's background or profession.

Fig. 14
BEATRICE GODWIN
Caricatures of Oscar Wilde as a pig and a jockey
c1888. Pen and ink,
22.9 x 18 cm.
Hunterian Museum and Art Gallery, University of Glasgow, Glasgow

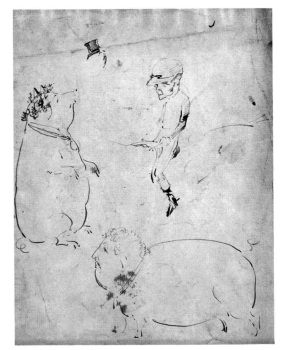

In his choice of lighting, Whistler favoured a low, quiet light, similar to that in which Hans Holbein (c1497–1543) placed his sitters, under which the flesh tones remain dim and in harmony with the rest of the colours. The dusky, atmospheric background enabled his subjects to 'live within their frame and stand upon their legs', as Whistler said of Velázquez's portraits. The Chicago lawyer, A J Eddy, observed that as the light began to fail, Whistler painted with ever-increasing urgency, 'until it seemed as if the falling of night was an inspiration'. Whistler himself explained why: 'As the light fades and the shadows deepen all petty and exacting details vanish, everything trivial disappears, and I see things as they are in great strong masses: the buttons are lost, but the garment remains; the garment is lost, but the sitter remains; the sitter is lost, but the shadow remains; the shadow is lost, but the picture remains. And that night cannot efface from the painter's imagination.'

One of Whistler's most striking and effective portraits is that of Théodore Duret (Plate 40), an intelligent French aristocrat, journalist and friend of Manet. Duret posed in evening dress, at Whistler's request, over a period of several months; each time Whistler decided to change a tone the entire canvas had to be rubbed down and repainted.

Aside from portraits, Whistler was much occupied in the 1880s with watercolour and with small oil panels of seascapes (painted at Dieppe, Dover, St Ives and Trouville) and of shopfronts. The charm of the latter lies in the locking together of tone and hue across the geometric structure of the façades. As the decade progressed they became looser in execution and more impressionistic, the grey base, on which many are painted, frequently playing an active part in the composition. Many of these small panels were painted in the company of two new followers, Walter Sickert (1860–1942) and Mortimer Menpes, who prepared the 'Master's' panels and accompanied him on his wanderings. In Chelsea, his eye was attracted to small incidents, such as Mortimer Menpes described: 'It might be a fish shop with eels for sale at so much a plate, and a few soiled children in the foreground; or perhaps a sweet shop, and the children standing with their faces glued to the pane' (Plates 42 and 43).

After two successful one-man exhibitions at Dowdeswells in 1884 and 1886, Whistler's reputation steadily began to mount. In 1884 he had the honour of being invited to become a member of the Society of British Artists and two years later was elected its president. It was an old-established society but in recent years its reputation had sunk and it was badly in need of someone with Whistler's flair for publicity to re-establish its position. He put his professionalism into practice as soon as he was elected president: the society's notepaper and signboard were redesigned; he insisted on a harsh jury, careful decoration of the gallery, and hung the paintings with ample space between each; he designed a kind of awning which hung from the ceiling and subdued the overhead lighting to a more sympathetic level. Selectivity, however, did not make for increased sales and gradually criticism began to be heard. 'I wanted to make the British Artists an art centre,' Whistler declared; 'they wanted to remain a shop.' In April 1888 he was asked to resign. Several of his followers left with him, causing him to remark, 'the artists have come out, and the British remain.' After his death *The Times* commented that the decision to make Whistler president 'was like electing a sparrow-hawk to rule a community of bats.'

In 1885 Whistler moved into a studio in Fulham Road and there painted *Harmony in Red: Lamplight* (Plate 45). Arms akimbo, the sitter,

Mrs Beatrice Godwin, appears as if caught in conversation with the artist. Her husband died in 1886 and two years later she became Whistler's wife. Plump, pretty, cheerful and a thorough Bohemian, she prepared for her second marriage simply by buying a new toothbrush and sponge. The daughter of the sculptor John Bernie Philip, she was also an artist in her own right and Whistler frequently turned to her for advice while painting his portraits. He regarded her not only as his marital partner, but as his companion-fighter in his battle with art, and would preface discussion of his progress in his letters with the term 'we'.

With Beatrice, Whistler moved to Paris in 1892, taking an apartment in the rue du Bac. He believed that the whole house should be a harmony of which the picture or print is only a part and spent as much care over its decoration as he had previously done on galleries for his one-man exhibitions. The reception room had blue and white panelled walls which harmonized with two blue paintings by Whistler and the stuffs that covered the few pieces of elegant furniture. From a Japanese birdcage hung trailing arrangements of flowers which ended in blue and white bowls and little tongue-shaped dishes.

One literary friendship that Whistler enjoyed in Paris was with Stéphane Mallarmé, the poet who regarded words as objects in their own right (as Whistler did forms and colours), yet allowed a plurality of allusions to gather to them. Whistler's 'Nocturnes' achieve their effect by omission. Mallarmé advised: 'To name an object is to suppress three-quarters of the pleasure...to suggest, there is the dream.' The two men were formally introduced by the Impressionist painter Claude Monet (1840–1926) in 1888 and soon after Mallarmé translated Whistler's *Ten O'Clock Lecture*. They carried on a lengthy correspondence and when in Paris Whistler would attend Mallarmé's celebrated *mardis* (literary gatherings). For the frontispiece to the poet's *Vers et Prose* published in 1893, Whistler executed a lithograph portrait of the poet, which, though apparently improvisatory, took several rejected efforts before it reached the allusive result, which hints, like Mallarmé's poems, at the whole (Fig. 15).

Lithography was the medium which in the 1890s took over from etching in Whistler's career because of its greater directness. 'Lithography reveals the artist in his true strength as draughtsman and colourist,' he wrote, 'for the line comes straight from his pencil and the tone has no further fullness than he himself, in his knowledge, gave it.' He could, in this medium, record the façade of a building with a handful of marks, leaving the eye, as in the late watercolours of Paul Cézanne (1839–1906), to span the gaps imaginatively. Several of the lithographs are of fashionable women, concerned with catching the tilt of a hat, an elegant pose or the outline of a modish dress.

Whistler's late years saw no radical change of direction or introduction of new matter into his art. He did, however, undergo an artistic crisis while staying at Lyme Regis in 1895 when his old uncertainty about the value of his work returned. He learned that his former desire to achieve the final result in one effortless *coup* was misleading and that, as he informed his wife, 'time is an element in the making of pictures! and haste is their undoing.' *The Master Smith of Lyme Regis* (Plate 48) is perhaps one of the paintings in which Whistler felt he emerged from his crisis in triumph.

Meanwhile Whistler's reputation had soared. In 1891 *Arrangement in Grey and Black No. 1: The Artist's Mother* was acquired by the French State and that same year Glasgow Corporation paid a thousand guineas for the portrait of Carlyle. Having exhibited at several important international exhibitions, Whistler was now awarded

Fig. 15
Stéphane Mallarmé
1892. Lithograph,
9.6 x 7 cm.
Freer Gallery of Art,
Washington DC

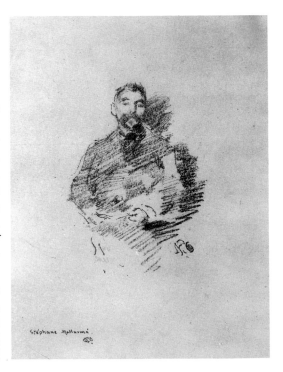

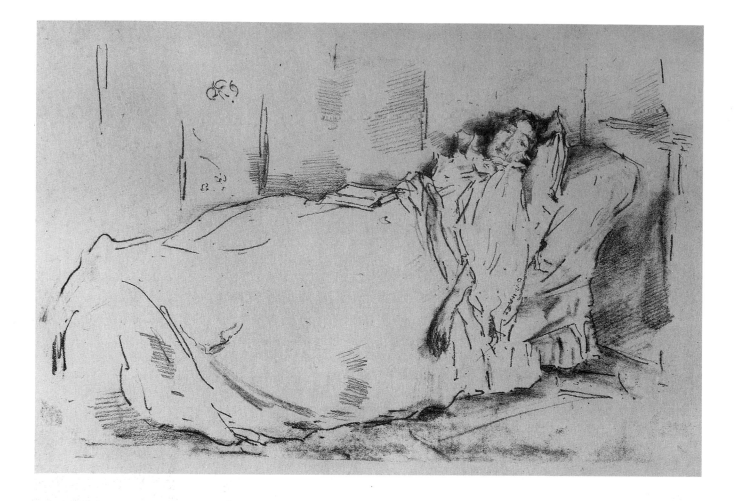

Fig. 16
The Siesta
1896. Lithograph,
13.7 x 21 cm.
British Museum, London

honours by Munich, Amsterdam and Paris. In London he was invited to exhibit at the New English Art Club and in Scotland was revered by the Glasgow School as the greatest living artist. In 1892 his one-man show at the Goupil Gallery in London caused the final turn-about in public feeling towards him and after this success the Duke of Marlborough commissioned his own portrait, but died before Whistler had time to begin work on it. A little bitter that commissions were only now coming in, Whistler declared, 'If I had had – say, £3,000 a year, what beautiful things I would have done.'

Since the Ruskin trial, Whistler's love of polemic had engaged him in frequent warfare in the Press and in the lawcourts. As a controversialist, he is celebrated by his *The Gentle Art of Making Enemies*, a collection of his writings published in 1890 with the dedication, 'To the rare Few, who, early in Life, have rid Themselves of the Friendship of the Many, these pathetic Papers are inscribed.' As well as reprinting offensive articles by art critics and his sardonic sallies in reply, the book contains his *Ten O'Clock Lecture* and his *Propositions* explaining his methods, and thus represents not only his wit but also his artistic philosophy. As with all his publications, the carefully considered typography and design were strikingly uncluttered by comparison with the standard practice of the day.

Whistler's desire to teach and preach found further outlet at the Académie Carmen in Paris, opened in 1898 by one of his models, Madame Carmen Rossi, and originally advertised as the Académie Whistler. Whistler agreed to act as visiting teacher, intending to offer the students his knowledge of a lifetime. He taught that art was a science, one step leading to another, and advised 'Distrust everything you have done without understanding it.' After a year or two his visits

became infrequent and in 1901 the school closed. Several of his pupils found his deep distrust of superficial effects discouraging, but the school is distinguished by one pupil alone, Gwen John (1876–1939), who developed a system of numbering her colour mixes in imitation of Whistler's scientific approach.

Since late 1894 Whistler had known that his wife was fatally ill with cancer. On a visit to London early in 1896 the couple put up at the Savoy Hotel, where Whistler executed lithographs of his wife, calling one *The Siesta* (Fig. 16), as if to convince himself that she was not dying, but only resting. From the hotel window he executed eight views of London which lack the easy notation of form found in his lithographs of Paris and suggest that they were drawn under stress. In the spring of 1896 he moved his wife to St Jude's Cottage, Hampstead, where in May she died. On the morning of her death Whistler was seen walking by a friend and could only say, 'Don't speak! Don't speak! It is terrible!'

After the death of his wife, Whistler became increasingly dependent on her mother and sister – the 'Ladies', as he referred to them. In May 1900 he asked Elizabeth and Joseph Pennell to undertake to write his life and spent much time during these last three years in their company, reminiscing and expounding his ideas on art. He continued to make frequent trips abroad, to Pourville, Paris, Tangier, Corsica and Ireland, and to produce small oils. Ill health gradually weakened his powers and during the last year of his life he was largely confined to the house in which he was then living, 74 Cheyne Walk, Chelsea, where he shuffled round the studio in a shabby fur-lined coat.

The deliberate limitation of subject-matter in Whistler's *œuvre* enabled him to concentrate more fully on the gradual refinement of his technique and on the use of radically simplified design that presages the twentieth-century concern with abstraction. He was the most intransigent, independent thinker in the English art world at a time when it was notoriously insular. Concerned with creating art and not commercial artefacts, he presided over the International Society of Sculptors, Painters and Gravers from 1898 until his death with the same professionalism that he exercised on the Society of British Artists: careful selection, decoration and hanging governed the exhibitions, and members were forbidden to belong to any other society. Yet emphasis on quality led him to underplay the emotional and intellectual content in art; his portraits, while asserting individuality, remain strangely impersonal. His art can be criticized for being too tasteful, too much a matter of nerves, too concerned with aesthetics, 'a plant without roots and bearing no fruit', as Sickert wrote in 1912. Often the subject is slight, but seizing on the thing seen, Whistler then made of an arbitrary pose stilled in mid-action, of a transient effect of light something ordered and permanent, thereby brushing with eternity a moment in time.

Fig. 17
Whistler in his
Fulham Road studio,
showing *Harmony in
Brown: The Felt Hat*
*c*1890. Photographs.
Library of Congress,
Washington DC

Outline Biography

1834 James Abbott McNeill Whistler born in Lowell, Massachusetts.

1843 Moves with his family to St Petersburg, Russia.

1851 Enters West Point, the military academy on the Hudson River. Stays three years.

1854 Brief period of employment in the United States Geodetic and Coast Survey offices in Washington where he learns to etch.

1855 Arrives Paris and enrolls in the studio of Charles-Gabriel Gleyre.

1859 Moves to London which remains his base until 1892.

1861 Painting trip to Brittany, followed by winter in Paris.

1863 Whistler's mother arives from America to live with him. Moves to 7 Lindsey Row, Chelsea, and becomes familiar with certain Pre-Raphaelites. Also befriends the Greaves brothers who deepen his love of the Thames. Begins to concentrate on Oriental subjects.

1865 Paints at Trouville in the autumn with Courbet.

1866 Travels to South America where the Chileans are engaged in a war against Spain. Keeps a journal of naval and military developments but avoids involvement in any fighting.

1867 Moves to 2 Lindsey Row (now 96 Cheyne Walk) where he lives for the next eleven years.

1869 Makes his first visit to Speke Hall, the home of the Liverpool shipowner, Frederick Leyland.

1871 Begins to paint a series of 'Nocturnes' based on the Thames at night.

1875 On doctor's advice, Mrs Whistler moves to Hastings where she spends the rest of her life. Whistler begins to entertain lavishly.

1876 Works on the decoration for the Peacock Room in Leyland's London house.

1877 Exhibits eight paintings at the opening exhibition of the Grosvenor Gallery, causing Ruskin to write in protest in *Fors Clavigera*. Whistler sues Ruskin for libel.

1878 The Whistler v. Ruskin trial. Whistler wins his case, is awarded a farthing damages and is bankrupted by the costs.

1879 Declared bankrupt. Bailliffs take possession of his house. Departs for Venice and stays there a whole year.

1883 An exhibition of his Venetian etchings at the Fine Art Society. The catalogue carries quotations from his earlier critics.

1884 Visits St Ives with Mortimer Menpes and Walter Sickert, painting small seascapes in oil and watercolour.

1886 Elected President of the Society of British Artists.

1888 Introduced to Stéphane Mallarmé who translates Whistler's *Ten O'Clock Lecture* into French and remains a close friend. Marries Beatrice Godwin.

1890 Publishes *The Gentle Art of Making Enemies*.

1892 Moves to Paris, taking an apartment in the rue du Bac; returns to London two years later.

1896 His wife dies.

1903 Whistler dies and is buried in Chiswick Cemetery.

Select Bibliography

Walter Dowdeswell, 'Whistler', *Art Journal*,
April 1887, pp.97-103

Arthur Jerome Eddy, *Recollections and
Impressions of James Abbott McNeill Whistler*,
Philadelphia and London, 1903

A E Gallatin, *Whistler's Art Dicta and other
Essays*, Boston, 1904

Mortimer Menpes, *Whistler as I Knew Him*,
London, 1904

T R Way, and G R Dennis, *The Art of James
McNeill Whistler: An Appreciation*, London,
1904

E R and J Pennell, *The Life of James McNeill
Whistler*, 2 vols., London, 1908

Edward G Kennedy, *The Etched Work of
Whistler*, New York, 1910

Frank Rutter, *James McNeill Whistler: An
Estimate and Biography*, London, 1911

Théodore Duret, *Whistler*, trans. Frank Rutter,
London, 1917

James Laver, *Whistler*, 2nd edition, London,
1951

Hesketh Pearson, *The Man Whistler*, London,
1952

Peter Ferriday, 'The Peacock Room',
Architectural Review, vol. cxxv, 1959,
pp.407-14

Carl Paul Barbier (ed.), *Correspondence
Mallarmé-Whistler: histoire de la grande
amitié de leurs dernières années*, Paris, 1964

Denys Sutton, *James McNeill Whistler: Paintings,
Etchings, Pastels and Watercolours*, London,
1966

Donald Holden, *Whistler Landscapes and
Seascapes*, New York, 1969

Tom Prideaux, *The World of Whistler 1834–1903*,
New York, 1970

From Realism to Symbolism: Whistler and his World,
exhibition catalogue, Wildenstein's, New
York, and Philadelphia Museum of Art,
Philadelphia, 1971

Roy McMullen, *Victorian Outsider*, London,
1974

Stanley Weintraub, *Whistler: A Biography*,
London, 1974

Mervyn Levy, *Whistler Lithographs: An
Illustrated Catalogue Raisonné*, London, 1975

Gordon Fleming, *The Young Whistler*, London,
1978

Hilary Taylor, *James McNeill Whistler*, London,
1978

Andrew McLaren Young, Margaret MacDonald
and Robin Spencer, *The Paintings of James
McNeill Whistler*, New Haven and London,
1980

Robin Spencer, *Whistler: A Retrospective*,
exhibition catalogue, Hugh Lauter Levin
Associates, New York, 1989

Richard Dorment and Margaret MacDonald,
Whistler, exhibition catalogue, Tate
Gallery, London, 1994

List of Illustrations

Colour Plates

1 Portrait of Whistler with Hat
1857/8. Oil on canvas, 46.3 x 38.1 cm.
Freer Gallery of Art, Washington DC

2 Head of a Peasant Woman
1855/8. Oil on wood, 25.9 x 18 cm.
Hunterian Museum and Art Gallery, University of
Glasgow, Glasgow

3 At the Piano
1858/9. Oil on canvas, 67 x 90.5 cm.
Taft Museum, Cincinnati, OH

4 The Thames in Ice
1860. Oil on canvas, 74.6 x 55.3 cm.
Freer Gallery of Art, Washington DC

5 Harmony in Green and Rose:
The Music Room
1860/1. Oil on canvas, 95.5 x 70.1 cm.
Freer Gallery of Art, Washington DC

6 Wapping
1861. Oil on canvas, 71.1 x 101.6 cm.
Private collection

7 Symphony in White No. 1: The White Girl
1862. Oil on canvas, 214.6 x 108 cm.
National Gallery of Art, Washington DC

8 The Last of Old Westminster
1862. Oil on canvas, 61 x 77.5 cm.
Museum of Fine Arts, Boston, MA

9 Brown and Silver: Old Battersea Bridge
1859/65. Oil on canvas, subsequently mounted on
prestwood, 63.5 x 76.2 cm.
Addison Gallery of American Art, Andover, MA

10 Caprice in Purple and Gold:
The Golden Screen
1864. Oil on wood, 50.2 x 68.7 cm.
Freer Gallery of Art, Washington DC

11 Purple and Rose: The Lange Lijzen
of the Six Marks
1864. Oil on canvas, 50.9 x 68.6 cm.
Philadelphia Museum of Art, John G Johnson
Collection, Philadelphia, PA

12 La Princesse du pays de la porcelaine
1864. Oil on canvas, 199.9 x 116 cm.
Freer Gallery of Art, Washington DC

13 Symphony in White No. 2: The Little
White Girl
1864. Oil on canvas, 76 x 51 cm.
Tate Gallery, London

14 The Artist's Studio
c1865. Oil on millboard, 62.2 x 46.3 cm.
Municipal Gallery of Modern Art, Dublin

15 Harmony in Blue and Silver: Trouville
1865. Oil on canvas, 49.5 x 75.5 cm.
Isabella Stewart Gardner Museum, Boston, MA

16 Blue and Silver: Trouville
1865. Oil on canvas, 59.1 x 72.4 cm.
Freer Gallery of Art, Washington DC

17 Crepuscule in Opal: Trouville
1865. Oil on canvas, 34 x 45.7 cm.
Toledo Museum of Art, Toledo, OH

18 Variations in Flesh Colour and Green:
The Balcony
1865. Oil on wood, 61.4 x 48.8 cm.
Freer Gallery of Art, Washington DC

19 Symphony in Grey and Green: The Ocean
1866. Oil on canvas, 80.7 x 101.9 cm.
Frick Collection, New York, NY

20 Crepuscule in Flesh Colour and
Green: Valparaiso
1866. Oil on canvas, 58.4 x 75.5 cm.
Tate Gallery, London

21 Symphony in White No. 3
1867. Oil on canvas, 52 x 76.5 cm.
Barber Institute of Fine Arts, University of
Birmingham, Birmingham

22 Variations in Blue and Green
1868. Oil on millboard, mounted on wood,
46.9 x 61.8 cm. Freer Gallery of Art, Washington DC

23 Battersea Reach from Lindsey Houses
Late 1860s. Oil on canvas, 76 x 51 cm.
Hunterian Museum and Art Gallery, University of
Glasgow, Glasgow

24 Symphony in Blue and Pink
c1870. Oil on millboard, mounted on wood,
46.7 x 61.9 cm. Freer Gallery of Art, Washington DC

25 Arrangement in Black: Portrait of
F R Leyland
1870. Oil on canvas, 192.8 x 91.9 cm.
Freer Gallery of Art, Washington DC

26 Symphony in Flesh Colour and Pink:
Portrait of Mrs Frances Leyland
1871–3. Oil on canvas, 195.9 x 102.2 cm.
Frick Collection, New York, NY

27 Symphony in Grey: Early Morning, Thames
c1871. Oil on canvas, 45.7 x 67.5 cm.
Freer Gallery of Art, Washington DC

28 Nocturne in Blue and Green
1871. Oil on canvas, 50 x 59.3 cm.
Tate Gallery, London

29 Arrangement in Grey and Black No. 1:
The Artist's Mother
1871. Oil on canvas, 144.3 x 162.5 cm.
Musée d'Orsay, Paris

30 Arrangement in Grey: Portrait of the Painter
1872. Oil on canvas, 74.9 x 53.3 cm.
Detroit Institute of Arts, Detroit, MI

31 Arrangement in Grey and Black No. 2:
Portrait of Thomas Carlyle
1872. Oil on canvas, 171 x 143.5 cm.
City Art Gallery, Glasgow

32 Nocturne: Blue and Silver –
Cremorne Lights
1872. Oil on canvas, 50.2 x 74.9 cm.
Tate Gallery, London

33 Nocturne: Blue and Gold –
Old Battersea Bridge
1872/3. Oil on canvas, 66.6 x 50.2 cm.
Tate Gallery, London

34 Harmony in Grey and Green:
Miss Cicely Alexander
1872–4. Oil on canvas, 190 x 98 cm.
Tate Gallery, London

35 Cremorne Gardens, No. 2
c1872/7. Oil on canvas, 68.5 x 135.5 cm.
Metropolitan Museum of Art, New York, NY

36 Nocturne in Black and Gold:
The Falling Rocket
1875. Oil on wood, 60.3 x 46.6 cm.
Detroit Institute of Arts, Detroit, MI

37 Arrangement in Brown and Black: Portrait
of Miss Rosa Corder
c1876. Oil on canvas, 192.4 x 92.4 cm.
Frick Collection, New York, NY

38 Harmony in Blue and Gold:
The Peacock Room
1876–7. Oil and gold leaf on leather and wood,
425.8 x 1010.9 x 608.3 cm.
Freer Gallery of Art, Washington DC

39 Nocturne in Blue and Silver:
The Lagoon, Venice
1879/80. Oil on canvas, 51 x 66 cm.
Museum of Fine Arts, Boston, MA

40 Arrangement in Flesh Colour and Black:
Portrait of Théodore Duret
1883–4. Oil on canvas, 193.4 x 90.8 cm.
Metropolitan Museum of Art, New York, NY

41 Grey and Silver: Mist – Lifeboat
1884. Oil on wood, 12.3 x 21.6 cm.
Freer Gallery of Art, Washington DC

42 A Shop
1884/90. Oil on canvas, 13.9 x 23.3 cm.
Hunterian Museum and Art Gallery, University of
Glasgow, Glasgow

43 An Orange Note: Sweet Shop
1884. Oil on wood, 12.2 x 21.5 cm.
Freer Gallery of Art, Washington DC

44 Chelsea Houses
c1880–7. Oil on wood, 13.3 x 23.5 cm.
Stanford University Museum and Art Gallery,
Stanford, CA

45 Harmony in Red: Lamplight
1886. Oil on canvas, 190.5 x 89.7 cm.
Hunterian Museum and Art Gallery, University
of Glasgow, Glasgow

46 Harmony in Blue and Gold:
The Little Blue Girl
1894–1901. Oil on canvas, 74.7 x 50.5 cm.
Freer Gallery of Art, Washington DC

47 The Little Rose of Lyme Regis
1895. Oil on canvas, 51.4 x 31.1 cm.
Museum of Fine Arts, Boston, MA

48 The Master Smith of Lyme Regis
1895. Oil on canvas, 51.4 x 31.1 cm.
Museum of Fine Arts, Boston, MA

Text Illustrations

1 The Coast Survey
 1854–5. Etching, 14.3 x 26 cm.
 British Museum, London

2 Scene of Bohemian Life
 1857–8. Pen and ink, diameter 23.8 cm.
 Art Institute of Chicago, Chicago, IL

3 GUSTAVE COURBET
 Burial at Ornans
 1848–50. Oil on canvas, 318.7 x 665.5 cm.
 Musée d'Orsay, Paris

4 The Kitchen
 1885. Etching, 22.5 x 15.6 cm.
 British Museum, London

5 Fumette Standing
 1859. Drypoint, 34.5 x 21.5 cm.
 British Museum, London

6 Finette
 1859. Drypoint, 28.9 x 20 cm.
 British Museum, London

7 CHARLES MEYRON
 The Morgue
 c1850-4. Etching, 21.3 x 18.7 cm.
 British Museum, London

8 Rotherhithe
 1860. Etching, 27.3 x 19.7 cm.
 British Museum, London

9 Weary
 1863. Drypoint, 19.7 x 138 cm.
 British Museum, London

10 HENRY AND WALTER GREAVES
 Cremorne Gardens, with a portrait of
 Whistler
 1870s. Pencil and grey wash, 48.9 x 61.6 cm.
 Private collection

11 Swinburne
 1870s. Drypoint, 27.6 x 18.6 cm.
 Freer Gallery of Art, Washington DC

12 Elinor Leyland
 1873. Drypoint, 21.3 x 14 cm.
 British Museum, London

13 The Doorway, Venice
 c1880. Etching and drypoint, 29.5 x 20.3 cm.
 Hunterian Museum and Art Gallery, University of
 Glasgow, Glasgow

14 BEATRICE GODWIN
 Caricatures of Oscar Wilde as a pig and a
 jockey
 c1888. Pen and ink, 22.9 x 18 cm.
 Hunterian Museum and Art Gallery, University of
 Glasgow, Glasgow

15 Stéphane Mallarmé
 1892. Lithograph, 9.6 x 7 cm.
 Freer Gallery of Art, Washington DC

16 The Siesta
 1896. Lithograph, 13.7 x 21 cm.
 British Museum, London

17 Whistler in his Fulham Road studio,
 showing *Harmony in Brown: The Felt Hat*
 c1890. Photographs.
 Library of Congress, Washington DC

Comparative Figures

18 Whistler
Date unknown. Photograph. National Portrait
Gallery, London

19 Head of Old Man Smoking
*c*1858. Oil on canvas, 41 x 33 cm.
Musée d'Orsay, Paris

20 HENRI FANTIN-LATOUR
The Artist's Two Sisters
1859. Oil on canvas, 98 x 130 cm.
St Louis Art Museum, St Louis, MO

21 Black Lion Wharf
1859. Etching, 15.2 x 22.6 cm. Tate Gallery, London

22 Black Eagle and Adjoining Wharfs, Wapping
*c*1860. Photograph. Tower Hamlets Library, London

23 SPENCER STANHOPE
Thoughts of the Past
1859. Oil on canvas, 86.4 x 50.8 cm.
Tate Gallery, London

24 SIR JOHN EVERETT MILLAIS
Autumn Leaves
1856. Oil on canvas, 104.3 x 74 cm.
Manchester City Art Galleries, Manchester

25 Battersea Reach
1863-4. Oil on canvas, 51 x 76 cm.
Corcoran Gallery of Art, Washington DC

26 GUSTAVE COURBET
The Seaside at Palavas
1854. Oil on canvas, 39 x 46 cm.
Musée Fabre, Montpellier

27 Grey and Silver: The Angry Sea
1884. Oil on panel, 12.4 x 21.7 cm.
Freer Gallery of Art, Washington DC

28 TORII KIYONAGA
The Sixth Month from *Twelve Months
in the South*
1784. Woodcut, 36.7 x 25.7 cm.
British Museum, London

29 Design for Butterfly
*c*1898. Pen and ink, 17.3 x 11.3 cm.
Hunterian Museum and Art Gallery, University
of Glasgow, Glasgow

30 ALBERT MOORE
Beads
*c*1875. Oil on panel, 29.8 x 51.4 cm.
National Gallery of Scotland, Edinburgh

31. ALBERT MOORE
Dreamers
1882. Oil on canvas, 68.5 x 119.4 cm.
Birmingham Museum and Art Gallery, Birmingham

32 The White Symphony: Three Girls
*c*1868. Oil on panel, 46.4 x 61.6 cm.
Freer Gallery of Art, Washington DC

33 ALBERT MOORE
Sea Shells
*c*1870. Oil on canvas, 157.5 x 70 cm.
Walker Art Gallery, Liverpool

34 Speke Hall
1870. Etching, 22.5 x 15 cm.
Walker Art Gallery, Liverpool

35 Fanny Leyland
*c*1872. Drypoint, 196 x 32 cm.
Freer Gallery of Art, Washington DC

36 Chelsea in Ice
*c*1864. Oil on canvas, 44.7 x 61 cm.
Private collection

37 Detail of Plate 29

38 WALTER GREAVES
Unloading the Barge: Lindsey Quay and
Battersea Church
*c*1860. Oil on canvas, 61 x 45.7 cm.
Kensington and Chelsea Library, London

39 The Interior of the Grosvenor Gallery
from the *Illustrated London News*, vol. LXXX, 1877

40 The Peacock Room, Princes Gate, showing
La Princesse du pays de la porcelaine and the
blue and white china on the shelves
1892. Photograph.
University of Glasgow Library, Glasgow

41 MORTIMER MENPES
Whistler: Five Studies
1880s. Drypoint, 17.5 x 15.1 cm.
New York Public Library, New York, NY

42 WALTER SICKERT
The Red Shop or The October Sun
*c*1888. Oil on panel, 26.7 x 35.6 cm.
Castle Museum, Norwich

43 Gold and Orange: The Neighbours
1880s. Oil on panel, 21.6 x 12.8 cm.
Freer Gallery of Art, Washington DC

Portrait of Whistler with Hat

1857/8. Oil on canvas, 46.3 x 38.1 cm. Freer Gallery of Art, Washington DC

Fig. 18
Whistler
Date unknown.
Photograph. National
Portrait Gallery, London

All his life Whistler was intensely aware of how he looked and took great care over his appearance (Fig. 18). When sent to the famous military academy, West Point, he had for a period been delighted to find himself 'very dandy in grey'. This self-portrait, done in Paris while he was still an art student, is less dandified than some of his later portraits and conveys a considerable depth of feeling. The critic Théodore Duret, who was a friend of Whistler, recorded how Whistler, as a young man, had been greatly impressed in the Louvre by a head of a young man wearing a beret by the seventeenth-century Dutch painter Rembrandt. Certainly it is this artist's example which seems to lie behind the degree of psychological penetration which animates this portrait. It is also very much in keeping with his perception of himself at the time, when still an art student, as a Bohemian.

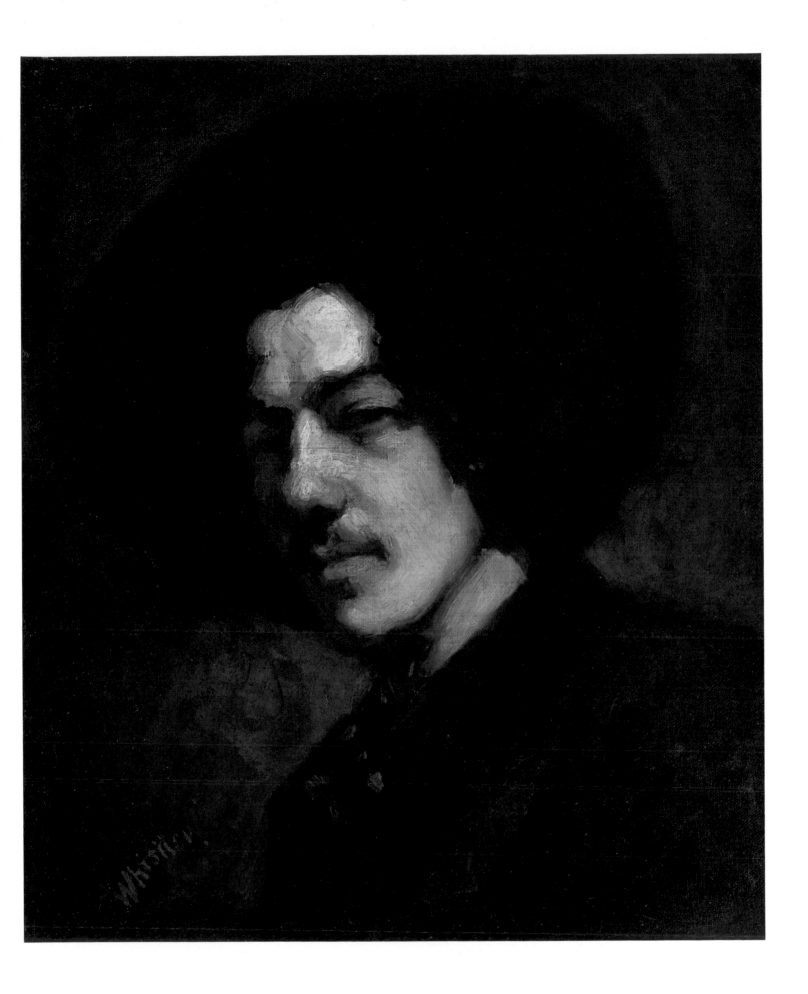

2 Head of a Peasant Woman

1855/8. Oil on wood, 25.9 x 18 cm. Hunterian Museum and Art Gallery,
University of Glasgow, Glasgow

Whistler, the young art student, arrived in Paris in 1855, the year that
Courbet erected a pavilion at his own expense to house his paintings after
the Salon rejected his *The Artist's Studio* and *Burial at Ornans* (Fig. 3). The
latter painting especially caused an uproar with its lack of idealization in
the row of mourners. Courbet's shocking realism inspired Whistler during
his student years in Paris to devote attention to proletarian subjects (Fig.
19). His *Head of a Peasant Woman*, however, is more thinly painted than
other examples of his work at this date and already shows his leaning
towards refined understatement. The paintwork is smooth and flat, as if
the surface had a 'skin', the quality which Whistler admired in
seventeenth-century Dutch painting, examples of which he saw on his
visit to the Exhibition of Art Treasures held in Manchester in 1857. This
revived his interest in the Old Masters. It also contained 14 paintings
attributed to Velázquez whom Whistler already regarded as an
unsurpassable master.

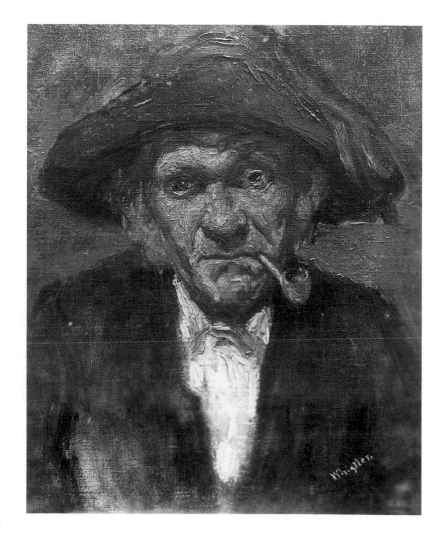

Fig. 19
Head of Old Man
Smoking
*c*1858. Oil on canvas,
41 x 33 cm.
Musée d'Orsay, Paris

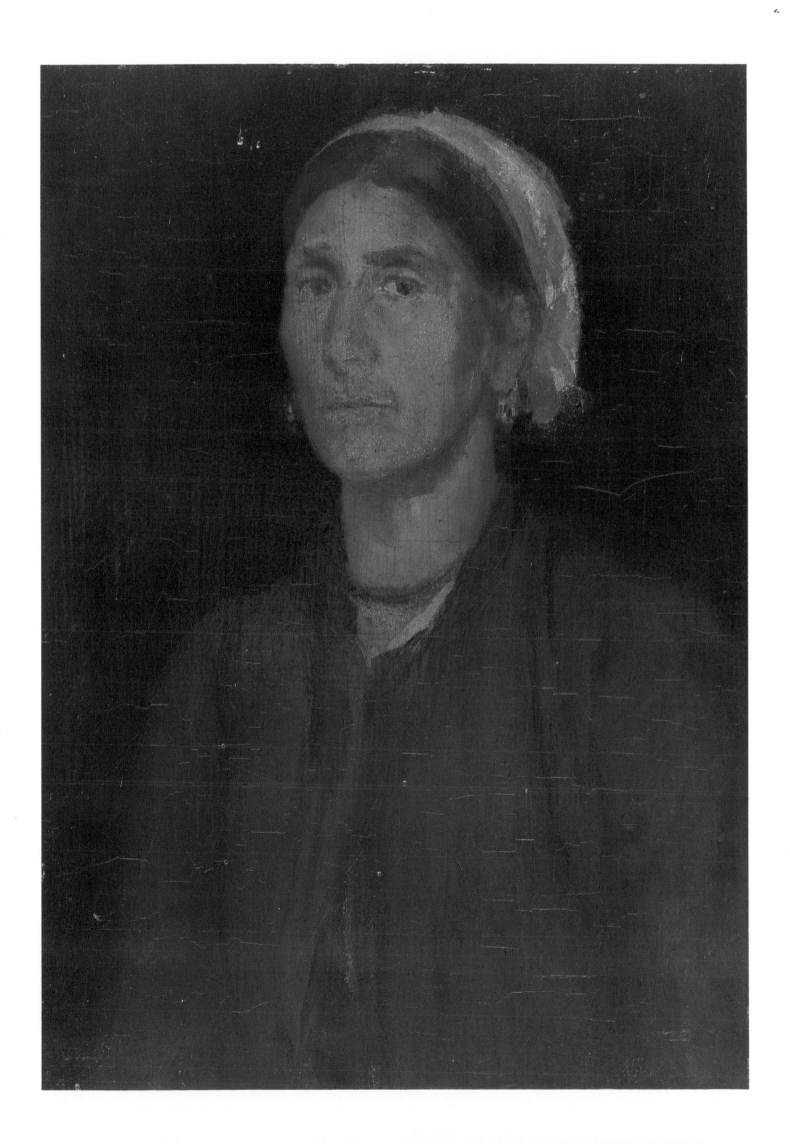

At the Piano

1858/9. Oil on canvas, 67 x 90.5 cm. Taft Museum, Cincinnati, OH

Whistler returned to London for Christmas 1858 and stayed with his brother-in-law, Francis Seymour Haden at 62 Sloane Street. This picture, showing his sister playing while her daughter stands listening, was begun in this house and completed in Paris early the following year from drawings and memory. Whistler gained much inspiration for his interiors from Dutch seventeenth-century painting and the design of *At the Piano* has the same calm order and inevitability as a work by Jan Vermeer (1632–1675) whose paintings Whistler may have studied in the National Gallery, London. He was at this time moving away from an imitation of Courbet's direct handling to a more refined realism. The stillness of the picture heightens the sensation of listening. Whistler not only enjoyed music but allowed it to direct his thinking on art. Aware of a profound correspondence between his artistic aims and his experience of music, he later began calling his paintings 'Symphonies', 'Nocturnes', 'Arrangements' and 'Harmonies', in this way drawing attention to their formal qualities. He was to paint a vivid portrait of the violinist Pablo Sarasate and here not only acknowleges his sister's musical gifts, but also those of her husband whose cello can be glimpsed beneath the piano alongside a violin.

In his choice of subject Whistler may have been influenced by his friend Fantin-Latour who likewise made use of two figures in close relationship in a domestic setting in *The Artist's Two Sisters* (Fig. 20). Both artists place their figures on opposite sides of the canvas, but in Fantin-Latour's the use of diagonals to create compositional movement gives it a see-saw rhythm, whereas Whistler's strict use of horizontals and verticals creates a more contemplative mood. The compositional severity of *At the Piano* is prevented from becoming too rigid by the slight bend in the dado on the wall behind, echoed in the line of the picture frames.

Fig. 20
HENRI FANTIN-
LATOUR
The Artist's Two
Sisters
1859. Oil on canvas,
98 x 130 cm.
St Louis Art Museum,
St Louis, MO

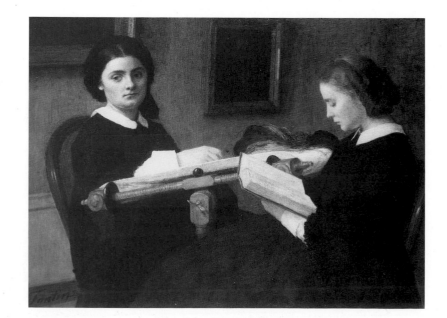

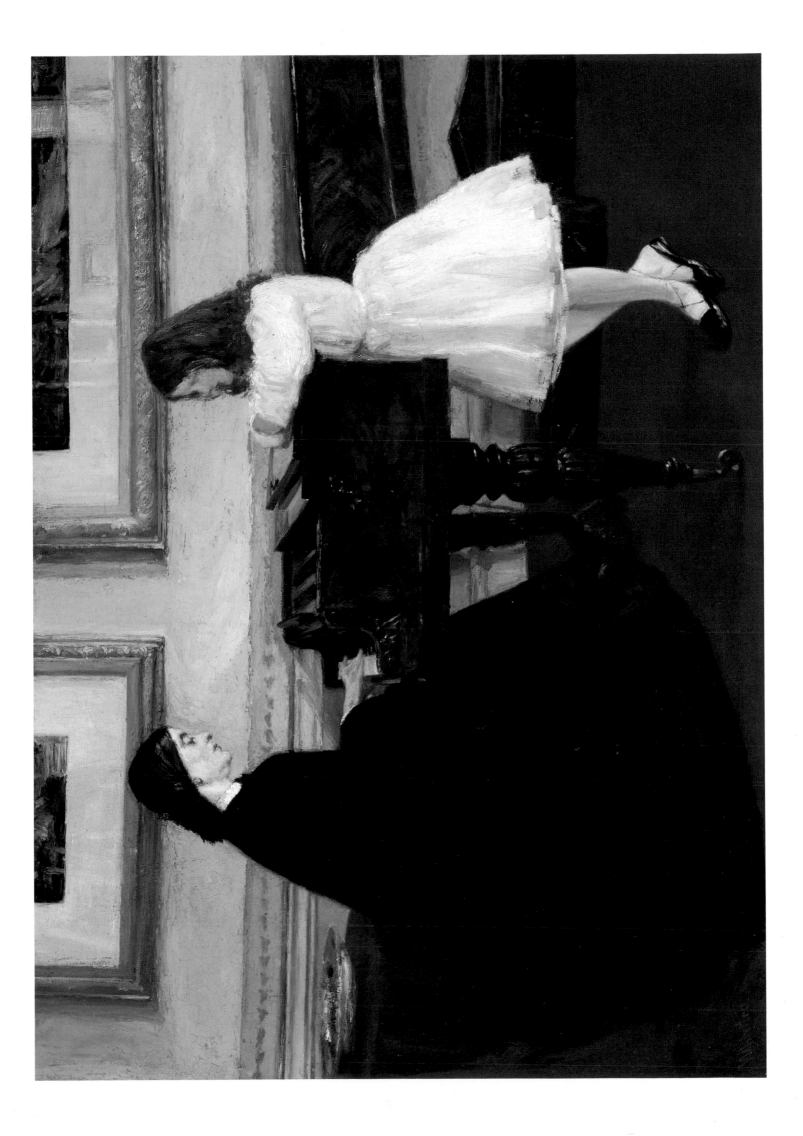

The Thames in Ice

1860. Oil on canvas, 74.6 x 55.3 cm. Freer Gallery of Art, Washington DC

It is probable that this was, like *Wapping* (Plate 6), painted at the Angel Inn, Rotherhithe, where Whistler stayed while working on this and other scenes based on this area (Fig. 21). Here he brilliantly evokes the chilly atmosphere of the river on a foggy, frosty morning. Mixing very little medium with his paint and using a loaded brush, he has dragged his whites across the weave of the canvas, in this way suggesting the harshness of snow and ice. The vigour of these strokes contrast with the delicacy of the rigging and the glimpse of distant factories whose chimneys gently belch smoke into the winter sky. The scene may have reminded Whistler of his childhood experience of the River Neva in St Petersburg, Russia, under ice, thereby satisfying Baudelaire's belief that 'genius is nothing more nor less than childhood recovered at will.'

Fig. 21
Black Lion Wharf
1859. Etching,
15.2 x 22.6 cm.
Tate Gallery, London

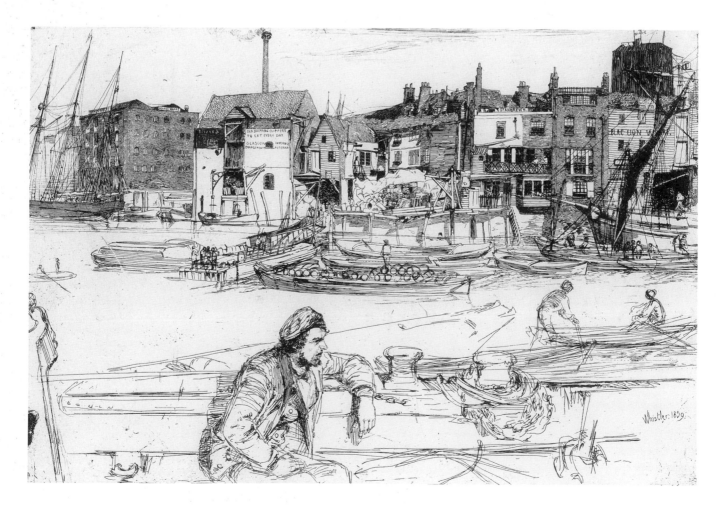

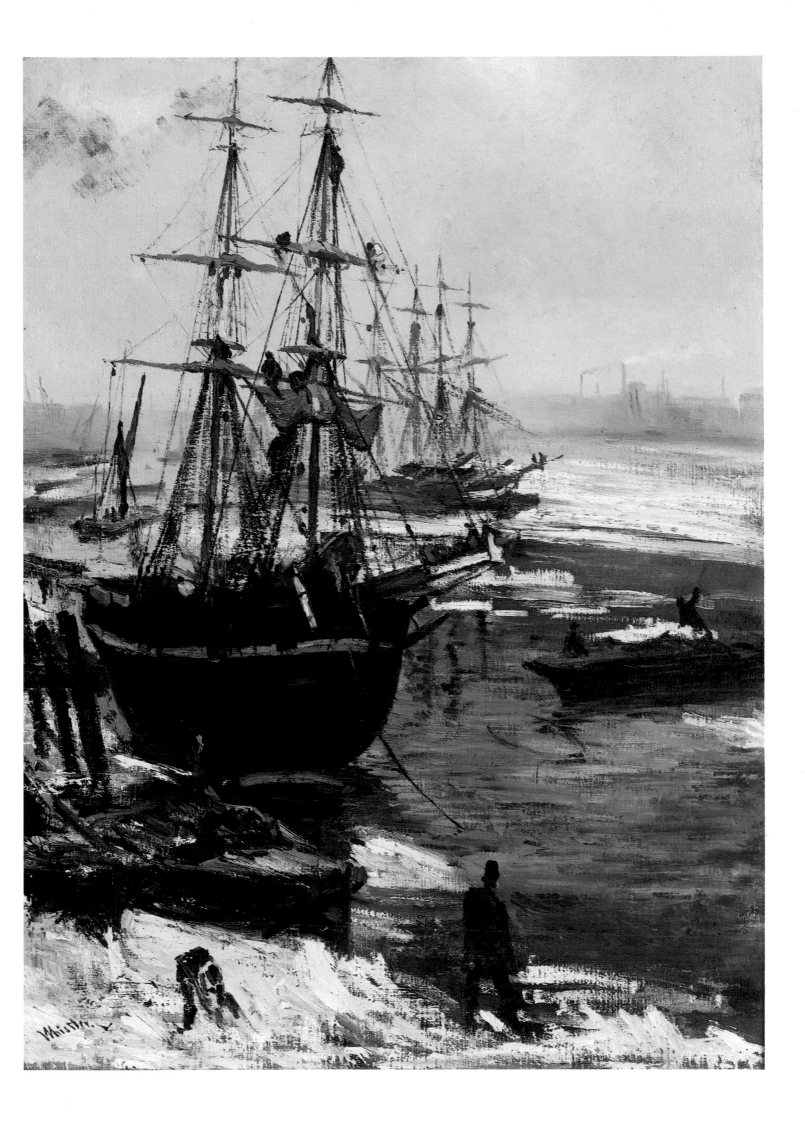

5

Harmony in Green and Rose:
The Music Room

1860/1. Oil on canvas, 95.5 x 70.1 cm. Freer Gallery of Art, Washington DC

According to Whistler's niece, Annie Haden, who is shown here seated in a white frock, this picture was painted in her parents' home at 62 Sloane Street. It was given by Whistler to his sister (Annie's mother), Deborah Haden, who appears as a reflection in the mirror on the left. The unusual composition and abrupt perspective make it far more advanced than anything the French painter Edgar Degas (1834–1917) had produced by this date. It is as if, after the quiet symmetry of *At the Piano*, Whistler felt the need to redesign radically his compositional elements, keeping, however, the bold contrast of black and white and letting the head of the standing figure again cut into the background picture frame to prevent the design from becoming too rigid.

The figure dressed in black riding clothes and about to take her leave is a friend of the family, the American Isabella Boott whose uncle founded the town Lowell, Massachusetts. Whistler shows each figure in its own separate space yet at the same time he manages to bind all three together in one corner of the room in a dense and surprisingly satisfying composition, deliberately contrasting the black bulk of the riding dress with the gaily-coloured chintz curtains. Whistler was to become the master of the standing portrait, often using a three-quarter view to suggest movement and thereby heighten our awareness of the transience of the human presence.

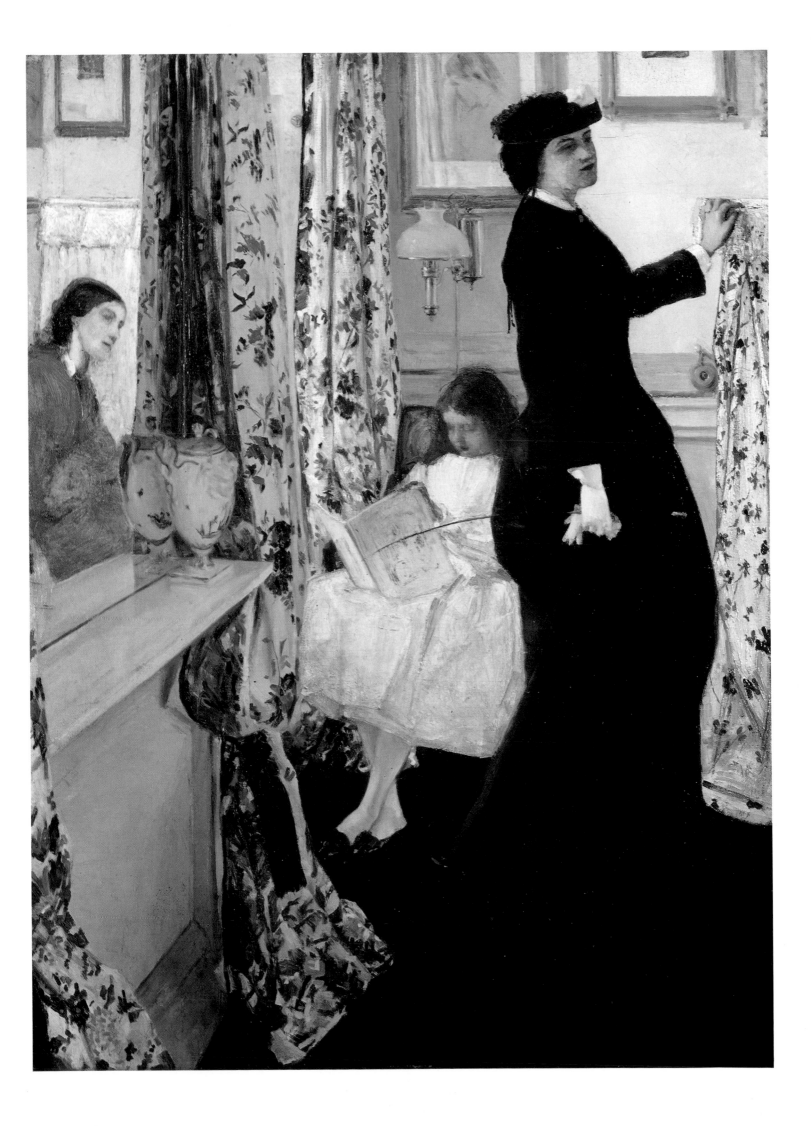

6 Wapping

1861. Oil on canvas, 71.1 x 101.6 cm. Private collection

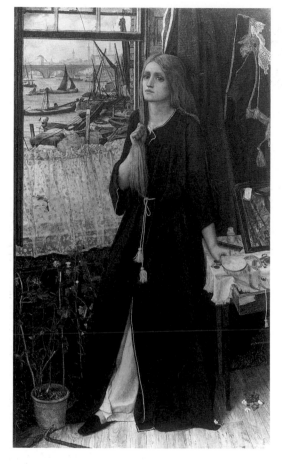

This is the picture which Whistler began working on in secret at Cherry Gardens, Rothcrhithe. He painted it at the Angel, an inn on the south side of the river which looked across from Rotherhithe to Wapping. This dockland area (Fig. 22) was rich in interest, noisy with the sounds of labour, pungent with the smells of merchandise being unloaded – tobacco, leather, rum, coffee and spice. While working on this picture Whistler sent a description of it to his friend Fantin-Latour in which he twice asked him not to mention anything about it to Courbet. His jealous guarding of his subject suggests that this picture had considerable importance for him. It is the most ambitious of his early river scenes and drew upon experience of this area which he had gained while making the 'Thames Set' etchings, one of which, *Rotherhithe* (Fig. 8), was drawn from the same balcony from which this oil was painted. The figures seated in the foreground are Whistler's mistress, Joanna Hiffernan, the artist Alphonse Legros and a sailor. Their quiet conversation throws into contrast the busy, confused scene behind. The colours in this painting have in places darkened and become more mute, leaving nowadays only the red chimney on a distant barge to create a colourful accent. The dockland scene, with the ragged confusion, suggests that Whistler at this time shared in the Pre-Raphaelites' interest in social realism. Whistler may also have been mocking the British love of story-telling in art, by choosing a subject unacceptable to a Royal Academy audience. A similar view can be seen through the window in Spencer Stanhope's *Thoughts of the Past* (Fig. 23), painted at Chatham Place, Blackfriars, where the painter Rossetti also lived and worked.

Fig. 23
SPENCER STANHOPE
Thoughts of the Past
1859. Oil on canvas,
86.4 x 50.8 cm.
Tate Gallery, London

Fig. 22
Black Eagle and
Adjoining Wharfs,
Wapping
*c*1860. Photograph.
Tower Hamlets Library,
London

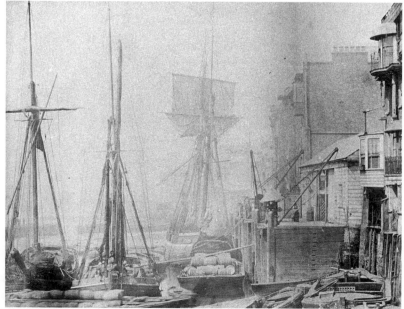

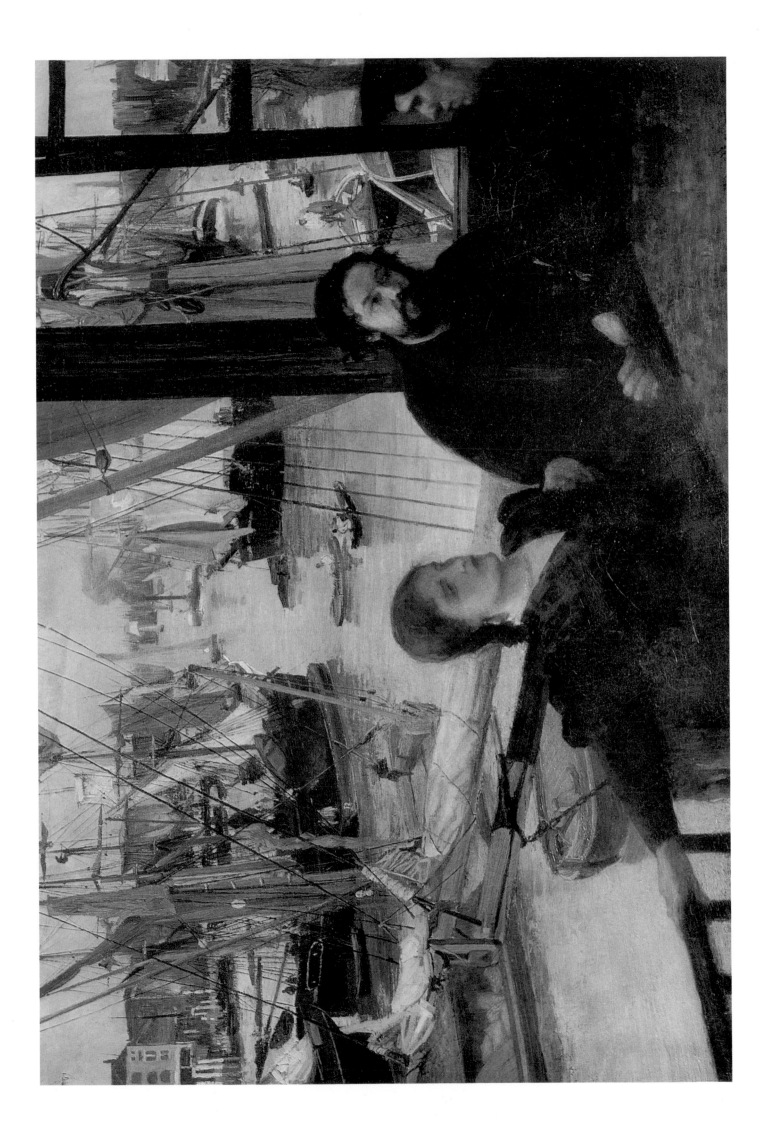

1862. Oil on canvas, 214.6 x 108 cm. National Gallery of Art, Washington DC

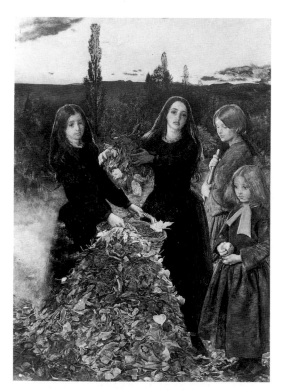

Fig. 24
SIR JOHN EVERETT
MILLAIS
Autumn Leaves
1856. Oil on canvas,
104.3 x 74 cm. Manchester
City Art Galleries,
Manchester

When this painting was first exhibited in London in 1862, Whistler objected to the title *Woman in White* and insisted that the painting had nothing to do with Wilkie Collins' novel of the same name. 'My painting', Whistler wrote, 'simply represents a girl dressed in white standing in front of a white curtain.' He later adopted for his title the phrase used by the critic Paul Mantz who referred to the picture in formal terms as a 'symphony in white'. When he used the title of this painting again in 1867 in connection with another painting of young women, it was criticized on account of other colours used. Whistler replied in characteristic vein: 'Bon Dieu! did the wise person expect white hair and chalked faces? And does he, then, in his astounding consequence, believe that a symphony in F contains no other note, but shall be a continued repetition of FFF?...Fool!'

Whistler had first submitted this painting for exhibition at the Royal Academy, but it had been rejected. When shown later that year at the Berners Gallery, where it caused much excitement in artistic circles, Whistler insisted that the catalogue carry the note 'Rejected at the Academy'. The following year he showed it at the Salon des Refusés in Paris where, with Manet's *Déjeuner sur l'herbe*, it enjoyed a *succès de scandale*.

The model for this picture was again Whistler's companion and mistress, Joanna Hiffernan, whose red hair glows dully amid the pale colours elsewhere. Whistler's decision to pose a woman wearing a white dress against a white ground astonished his contemporaries. The girl's far-seeing gaze may have been inspired by the central child in Millais's *Autumn Leaves* (Fig. 24). Whistler was determined at this time to shed the heaviness of Courbet's realism in favour of an approach more enigmatic in content. Courbet was himself disappointed in this painting, finding in it 'une apparition du spiritisme', (a spiritual apparition) which suggests that Whistler had succeeded in his aim.

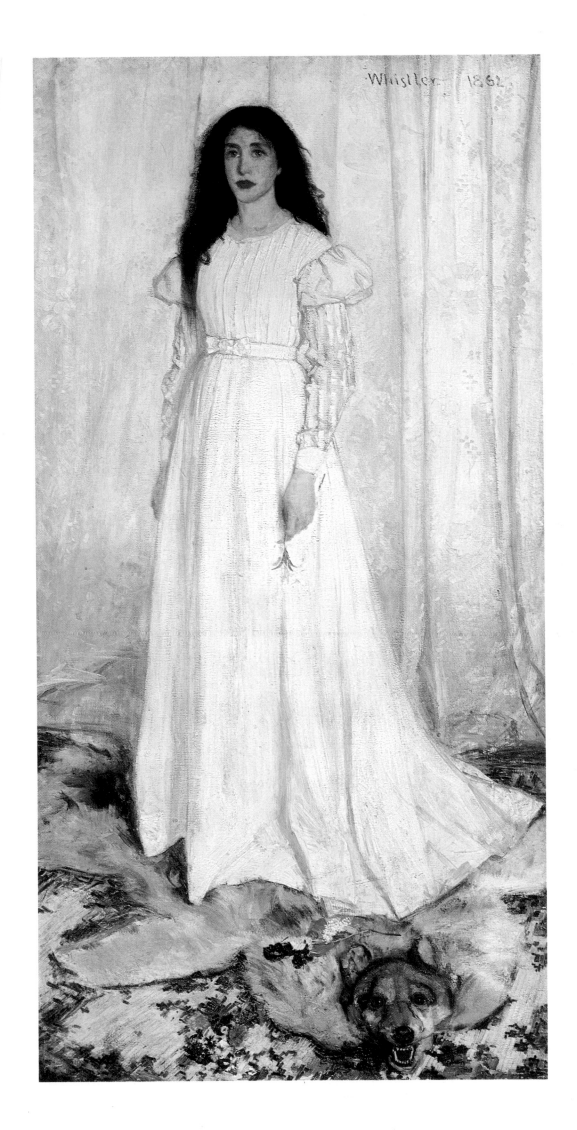

The Last of Old Westminster

1862. Oil on canvas, 61 x 77.5 cm. Museum of Fine Arts, Boston, MA

Whistler's choice of title for this picture has caused confusion. According to newspaper reports the old Westminster Bridge was rapidly being pulled down in October 1860, two years before the date which the artist inscribed on this canvas. A new bridge, built on the same alignment, went up as the old one was taken down and by the end of October 1860 traffic was passing over it. Whistler painted this scene from the rooms of a civil servant and amateur artist, Walter Severn, who lived in Manchester Buildings on the site of the present Scotland Yard. He told Whistler's biographer, the Pennells, that what fascinated Whistler was not so much the bridge itself but the wooden piles used as scaffolding while work progressed. It was a difficult subject to paint, for every day the scene changed as work progressed. Whistler responded to the bustle and energy in front of his eyes by repainting several passages, altering the facts in response to what he saw. As a result the picture has a much greater sense of immediacy than *Brown and Silver: Old Battersea Bridge* (Plate 9) and achieves a different kind of success.

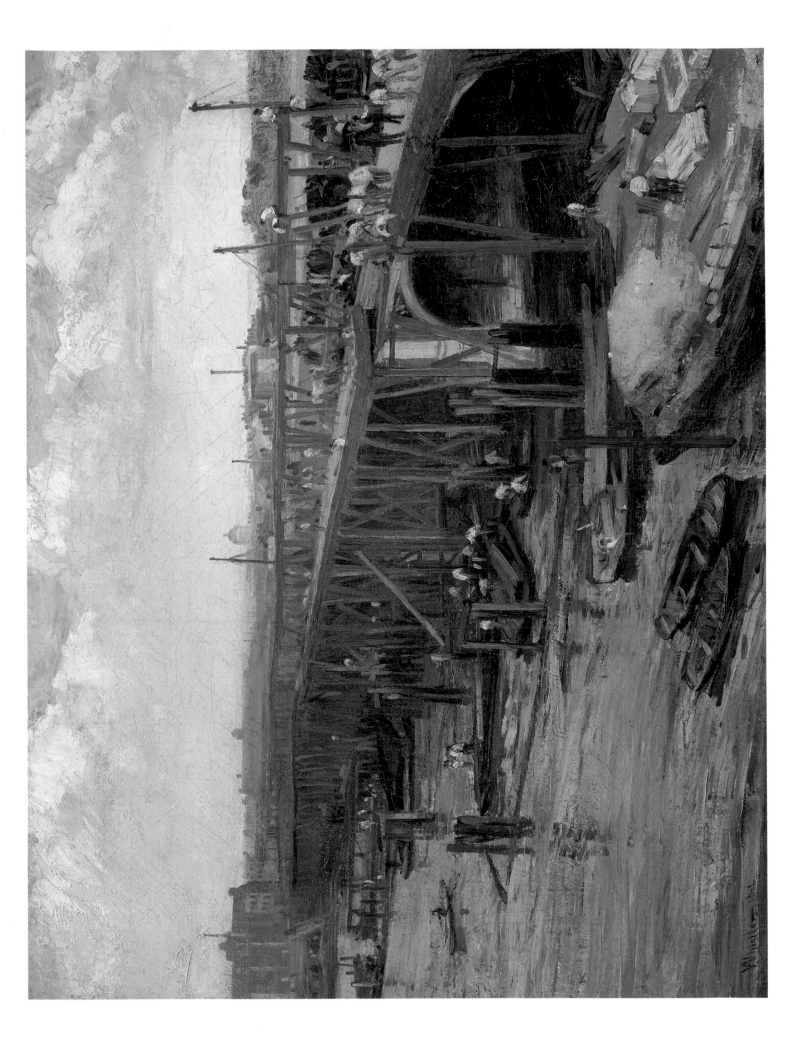

Brown and Silver: Old Battersea Bridge

1859/65. Oil on canvas, subsequently mounted on prestwood, 63.5 x 76.2 cm.
Addison Gallery of American Art, Andover, MA

Whistler's fascination with the River Thames began immediately after his arrival in London in 1859. His move to Chelsea in 1863 placed him in close proximity to it. From the window of his house in Lindsey Row (now Cheyne Walk, Chelsea) he looked across the river towards Battersea, a view he often painted (Fig. 25).

This painting was commissioned by Alexander C Ionides, father of a wealthy Greek shipping family who were loyal patrons of the arts and entertained Whistler and others in their house at Tulse Hill. One of the daughters of this family married Whistler's younger brother William. Whistler's affection for this family may explain why he felt able to work in his own time on this painting which was not publicly exhibited until 1865. Stylistically it appears later in date than *The Last of Old Westminster* (Plate 8) for though still thickly painted, the colours are muted and subjected to a carefully ordered tonality. And though reliant on the facts of the scene, Whistler has so arranged the ingredients as to set up visual echoes in the diagonals and small vertical accents created by boats, bridge, chimneys and figures. The distilled, wistful mood prefigures the dream-like quality of his later 'Nocturnes'.

Fig. 25
Battersea Reach
1863–4. Oil on canvas,
51 x 76 cm.
Corcoran Gallery of Art,
Washington DC

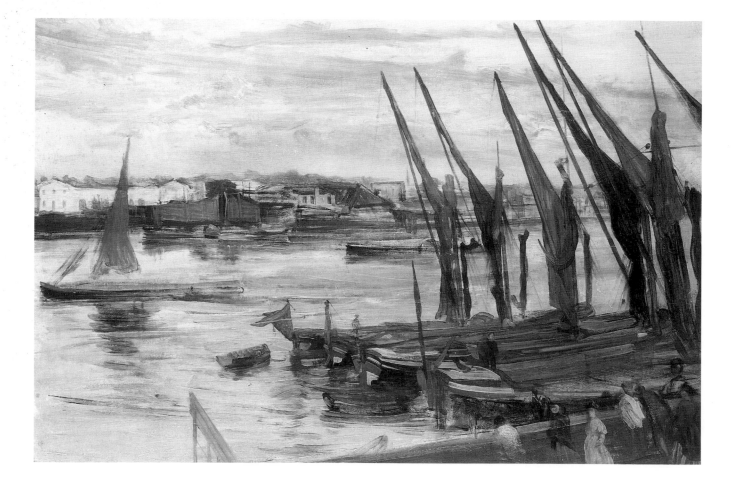

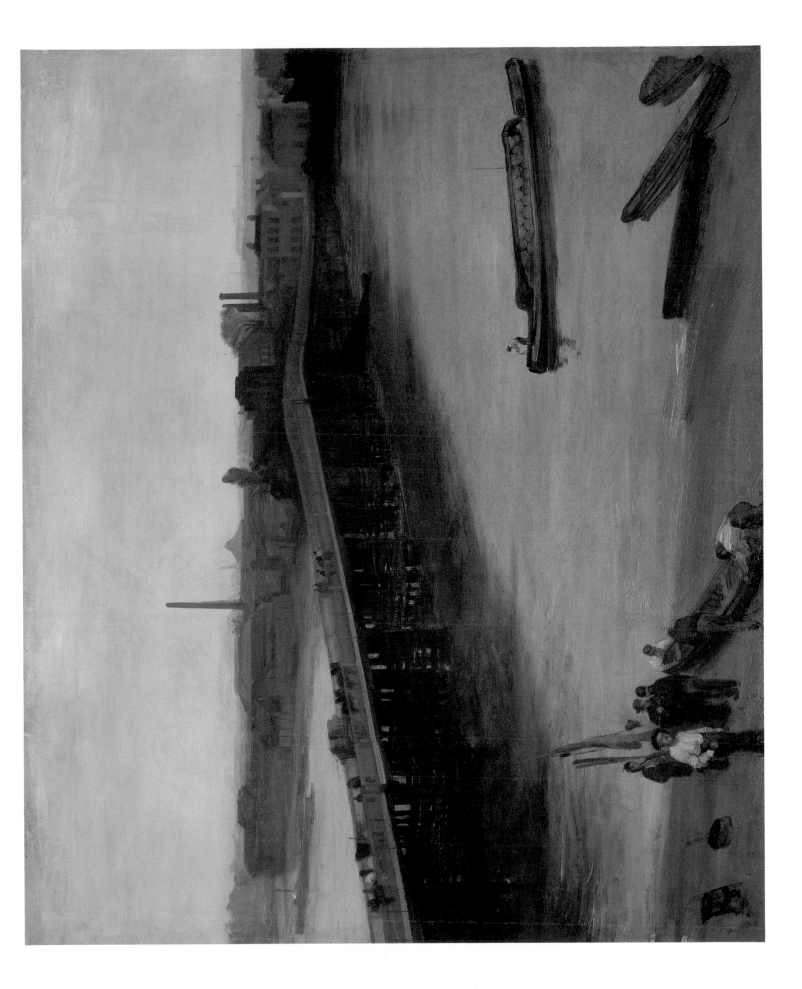

10 Caprice in Purple and Gold:
The Golden Screen

1864. Oil on wood, 50.2 x 68.7 cm. Freer Gallery of Art, Washington DC

Whistler's interest in Japanese art, especially prints, led him to create pictures using *japonaiserie*. Surrounded as this figure is here with Japanese objects, the picture amounts to a homage to another culture. The prints are recognizably those of the Japanese artist Andô Hiroshige (1797–1858), but the screen would appear to have no specifically identifiable source. The model was almost certainly Joanna Hiffernan who also appears in *Wapping* (Plate 6). She was Whistler's mistress for a while in the 1860s, keeping house for him and managing his affairs. Red-haired and Irish, she called herself Mrs Abbott to give herself respectability. Aware of her beauty, she liked fine clothes and could act the *grande dame*. She also flirted with Courbet whilst visiting Trouville with Whistler and in other ways created strain and difficulty. Whistler's sister was forbidden by her husband, the surgeon and etcher Haden, from visiting her brother while Jo, as she was called, remained in residence in Whistler's house.

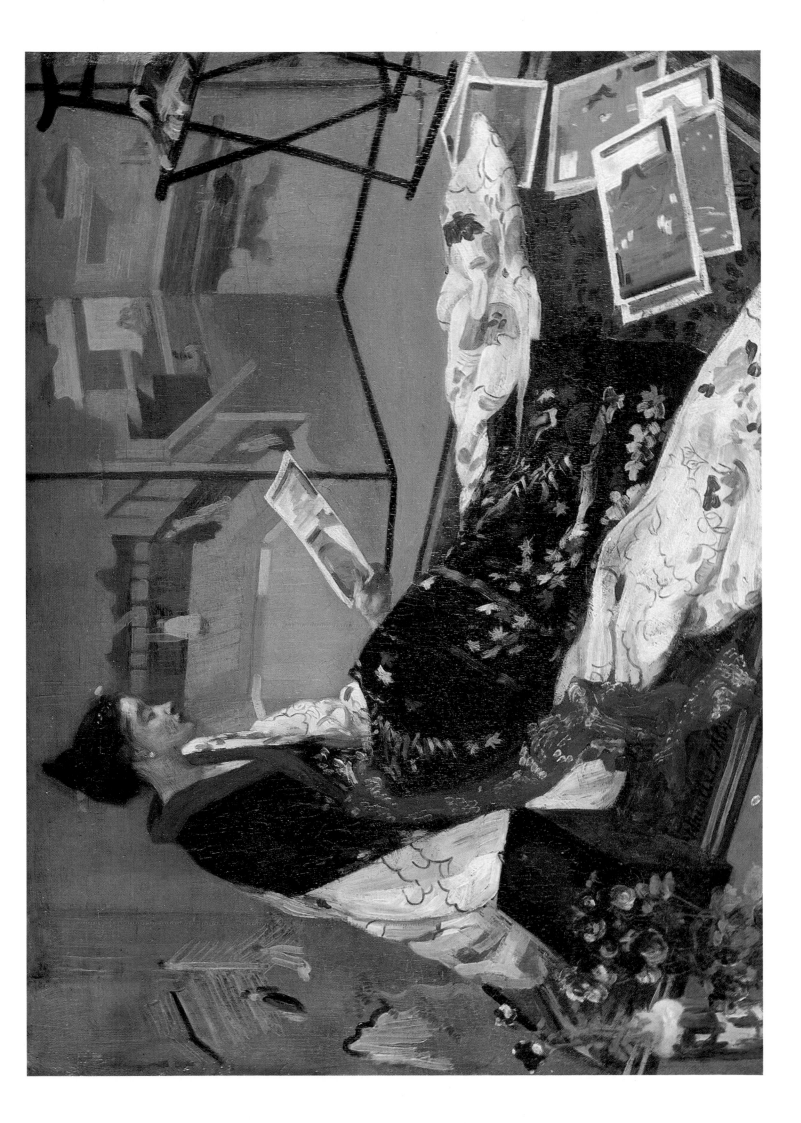

Purple and Rose: The Lange Lijzen of the Six Marks

1864. Oil on canvas, 50.9 x 68.6 cm. Philadelphia Museum of Art,
John G Johnson Collection, Philadelphia, PA

Whistler was a collector of blue and white Chinese porcelain and in a letter to Fantin-Latour claimed that all the items in this picture were in his possession. 'Lange Lijzen', Dutch for 'long Elizas', is the Delft name for blue and white Chinese porcelain decorated with figures of 'long ladies'. The 'Six Marks' are the potter's, giving the signature and date on the bottom of the vases. Through Rossetti, Whistler had met the dealer in oriental porcelain, Murray Marks. In 1876 Marks was to commission Whistler to execute illustrations for a catalogue of blue and white china in the collection of Kerry Thompson. This picture celebrates Whistler's interest in *japonaiserie*. It shows Whistler's mistress, Jo, dressed in a magnificent Chinese robe, in the act of painting a pot. Whistler has even signed the picture in a Japanese style. But these accoutrements apart, the painting is more Victorian than Oriental, the treatment of space and chiaroscuro still very much part of the western Renaissance tradition. Yet here and in subsequent paintings, Whistler attempted to imitate the fluidity and assurance with which Oriental potters drew on their jars. He began to use thinner paint and this, combined with the Japanese emphasis on selection and flat-patterning, cut across the French emphasis on painterliness and led away from the pursuit of form.

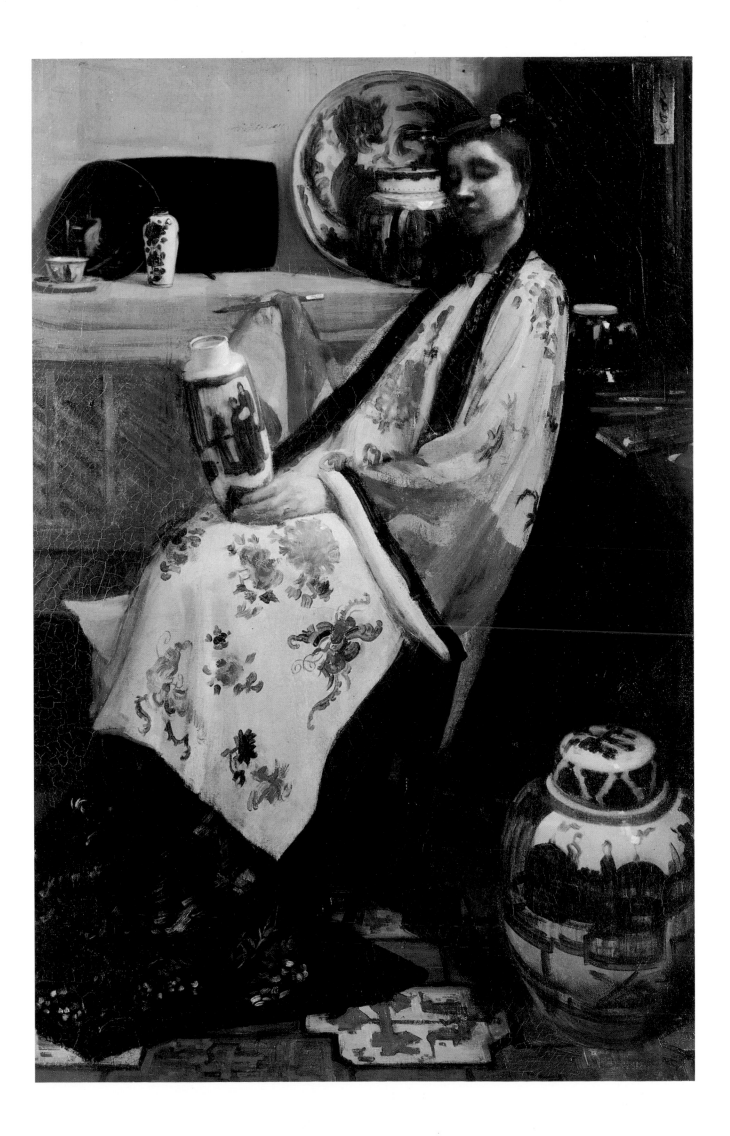

La Princesse du pays de la porcelaine

1864. Oil on canvas, 199.9 x 116 cm. Freer Gallery of Art, Washington DC

Though not the original owner, Frederick Leyland acquired this picture in time for it to become a focal point in the Peacock Room, designed by Whistler in Leyland's house, 49 Princes Gate. It was a picture which had caused the artist enormous difficulty and which he rated highly. The model was Christine Spartali whose sister, Marie Stillman, told how Whistler partly closed the shutters while he painted to shut out direct light. He also placed the canvas beside the model and, after looking at the canvas from a distance, would dash at it, adding one stroke of the brush before moving away again. Often at the end of the day he scraped down what he had painted and began again at the next sitting. When Christine Spartali fell ill, Whistler obtained another model to pose in her gown until the original sitter could resume her role.

When the *Glasgow Herald* critic announced his preference for this picture over the portrait of Carlyle, Whistler wrote: 'Such nonsense about joyousness and period – the picture takes its place simply with all the others and differs in no way from the portrait of Carlyle, excepting in so much as Carlyle himself, dear old Gentleman, differs from a young lady in a Japanese dressing gown.'

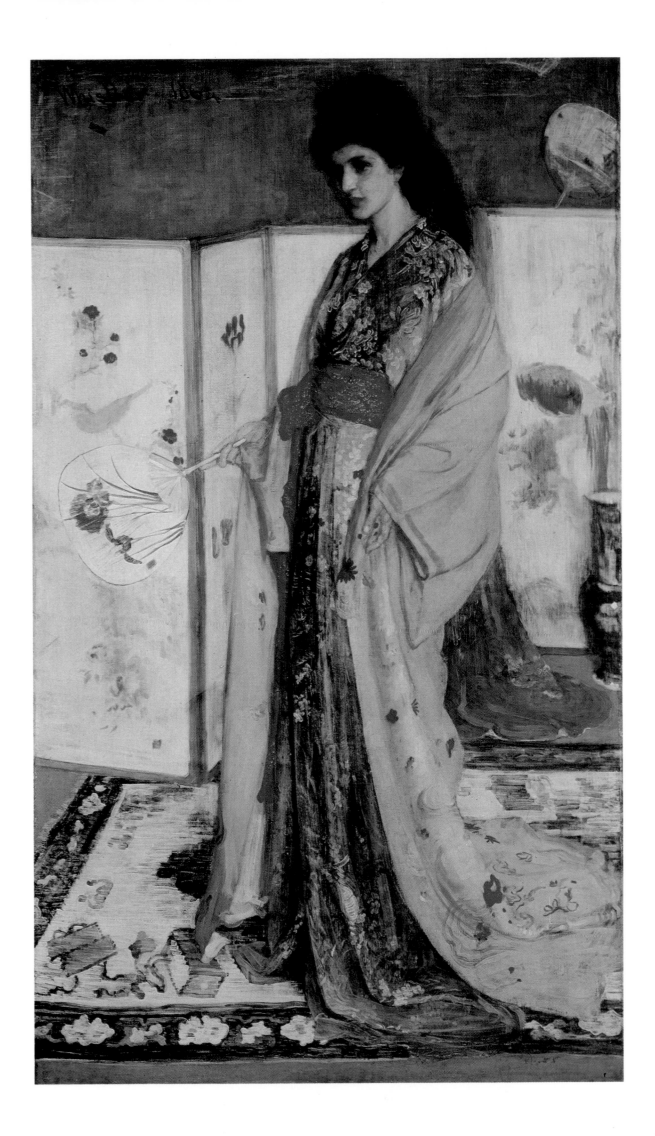

13 Symphony in White No. 2: The Little White Girl

1864. Oil on canvas, 76 x 51 cm. Tate Gallery, London

This is the most famous of all Whistler's paintings which use Japanese items to enliven an essentially Victorian subject. The model is again Joanna Hiffernan and the fireplace and mirror are the same as those shown in a contemporary photograph of the house in Lindsey Row where Whistler lived. Swinburne was so moved by this picture he wrote a poem, *Before the Mirror: Verses under a Picture* which, when printed, was attached to the original frame on gilt paper. According to the critic of *The Times* the picture had 'written round its frame some very beautiful, but not very lucid verses by Mr Swinburne, addressed to the picture, which is of a woman clad in white and very truthfully painted muslin...the picture is one...which means more than it says, though not so much as perhaps the poet has said for it. Thought and passion are under the surface of the plain features, giving them an undefinable attraction.' Whistler's love of direct painting is best seen in the fast brushstrokes used here to delineate the lightness of muslin.

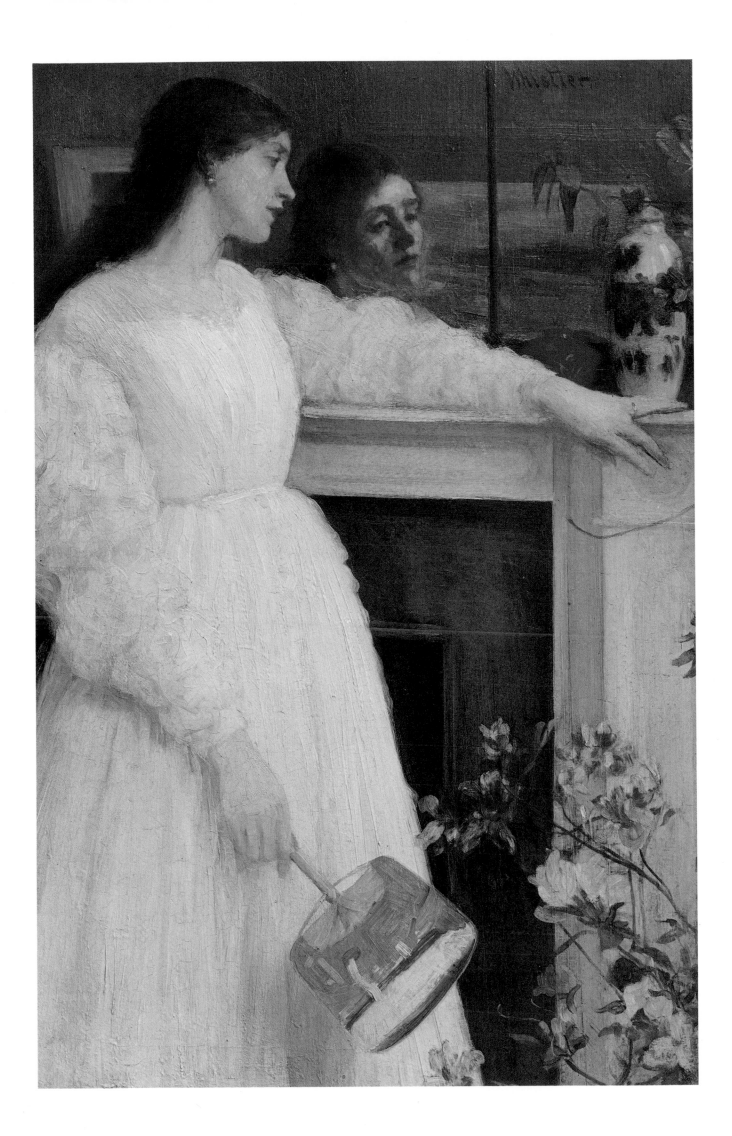

The Artist's Studio

c1865. Oil on millboard, 62.2 x 46.3 cm. Municipal Gallery of Modern Art, Dublin

This is one of two paintings on the same subject, both of which were intended as studies for a larger picture which Whistler announced he was going to send to the Salon in 1866, with the hope that it would scandalize the Academicians. There is no evidence that Whistler ever started work on the big canvas, perhaps because this and the other study for it were satisfying enough – a celebration of his interests, his mistress, his love of beauty and, of course, himself.

If compared with Courbet's *The Artist's Studio* (Musée d'Orsay, Paris), which Whistler saw on his arrival in Paris in 1855, we can see how dematerialized his vision has become in its fastidious pursuit of the succinct and elegant.

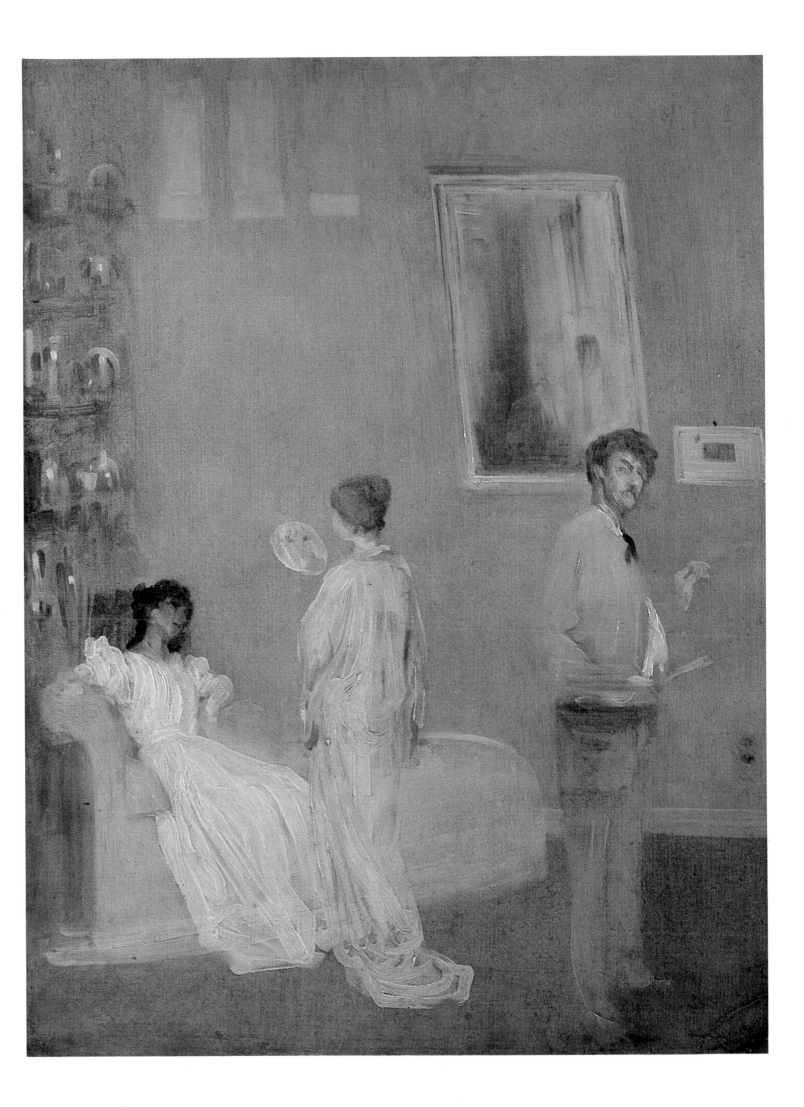

Harmony in Blue and Silver: Trouville

1865. Oil on canvas, 49.5 x 75.5 cm. Isabella Stewart Gardner Museum, Boston, MA

In the autumn of 1865 Whistler and Courbet worked together at Trouville. In a letter to his father, written on 17 November 1865, Courbet referred to Whistler as his pupil. Certainly Whistler used Courbet's *The Seaside at Palavas* (Fig. 26) with its small figure of a man in the lower left corner, as the starting point for this picture, but he may have done so with the deliberate intent to assert his differences from Courbet. Whereas the waves in Courbet's sea run in on a slight diagonal tilt, Whistler's sea is flatter, the horizontal emphasis more pronounced. His paint is thinner, his vision more dematerialized. The small figure in the lower left makes no gesture and his stillness, echoed in the vertical sail in the middle distance, sets up a greater sense of spaciousness than is found in Courbet's seascape. Despite his proximity to the great French artist, Whistler is already confident of his own artistic vision which was to flower more fully in the 1870s. We can, however, see already his ruthless excision of detail in his search for absolute simplicity of means.

Fig. 26
GUSTAVE COURBET
The Seaside
at Palavas
1854. Oil on canvas,
39 x 46 cm.
Musée Fabre, Montpellier

Blue and Silver: Trouville

1865. Oil on canvas, 59.1 x 72.4 cm. Freer Gallery of Art, Washington DC

In October 1865 Whistler wrote from Trouville to his friend and patron Luke Ionides: 'I am staying here to finish two or three seascapes which I wish to bring back with me. I believe they will be fine – and worth quite anything of the kind I have ever done. This is a charming place – although now the season is quite over and everyone has left – but the effects of sea and sky are finer than during the milder weather.' He wrote again to Ionides at the end of this month: 'The Sea is splendid at this moment but I am anxious to get back'. At least five pictures were produced at Trouville. Alterations to the lower left removed the two figures originally placed on the beach. The relationship between the boats and the rocks creates a visual tension that helps the eye move across the sea into space. The dominant effect, however, is one of luminosity created by the colours in the sky.

1865. Oil on canvas, 34 x 45.7 cm. Toledo Museum of Art, Toledo, OH

Despite the rich and luscious effect of this post-sunset sky, the picture is painted economically with relatively thin layers of paint, some scraped on with the palette knife. When Whistler held an exhibition of his work at the Goupil Gallery in 1892, he incorporated into the catalogue derogatory remarks made by critics of his work. When repeated alongside certain examples of his work the critics' views were shown to be either fatuous, blind or inaccurate. Under this painting Whistler added a criticism from the *Artist*: 'We want not always the blotches and misty suggestions of the impressionist.' All his life Whistler enjoyed painting the sea, cleverly using the fluidity of paint to suggest the movement of cloud, sail or wave (Fig. 27). As his pupil Walter Sickert observed: 'He will give you in the space of nine inches by four an angry sea, piled up, and running in, as no painter ever did before.'

Fig. 27
Grey and Silver: The Angry Sea
1884. Oil on panel,
12.4 x 21.7 cm.
Freer Gallery of Art,
Washington DC

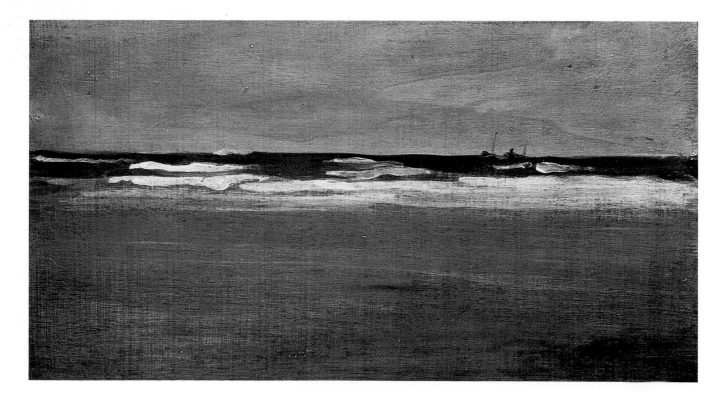

18 Variations in Flesh Colour and Green: The Balcony

1865. Oil on wood, 61.4 x 48.8 cm. Freer Gallery of Art, Washington DC

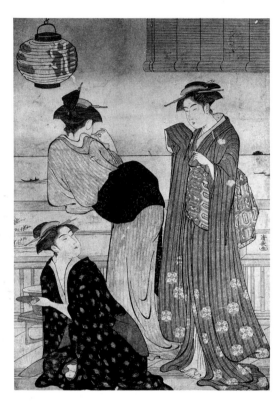

Fig. 28
TORII KIYONAGA
The Sixth Month
from *Twelve Months in
the South*
1784. Woodcut,
36.7 x 25.7 cm.
British Museum, London

Fig. 29
Design for Butterfly
*c*1898. Pen and ink,
17.3 x 11.3 cm.
Hunterian Museum and
Art Gallery, University of
Glasgow, Glasgow

This is another instance of Whistler's love of hybrid compositions, the chimneys in the background coming from Battersea, the figures on the balcony, the instrument, fan and tray of porcelain alluding to Japan. Possible Japanese sources are woodcuts by Haronobu and Torii Kiyonaga (Fig. 28). Story has it that Whistler acquired some Japanese dolls from a furniture restorer who later claimed he saw them on exhibition at the Royal Academy where this picture was exhibited in 1870. It is possible, therefore, that these dolls stood in as models for some or all of the figures in this picture.

Whistler places his figures against a horizontal and vertical framework and uses the standing figure leaning on the balcony to unite the foreground with the distant view. He also uses the Japanese saucers in one corner to frame the composition. Although piecemeal in its composition, the painting is held together by the tension between three-dimensional representation and two-dimensional design. This is clearly seen in the play upon illusion and reality in the lower left corner where a real butterfly crosses the flat tablet containing the butterfly signature that Whistler adopted around 1866 (Fig. 29).

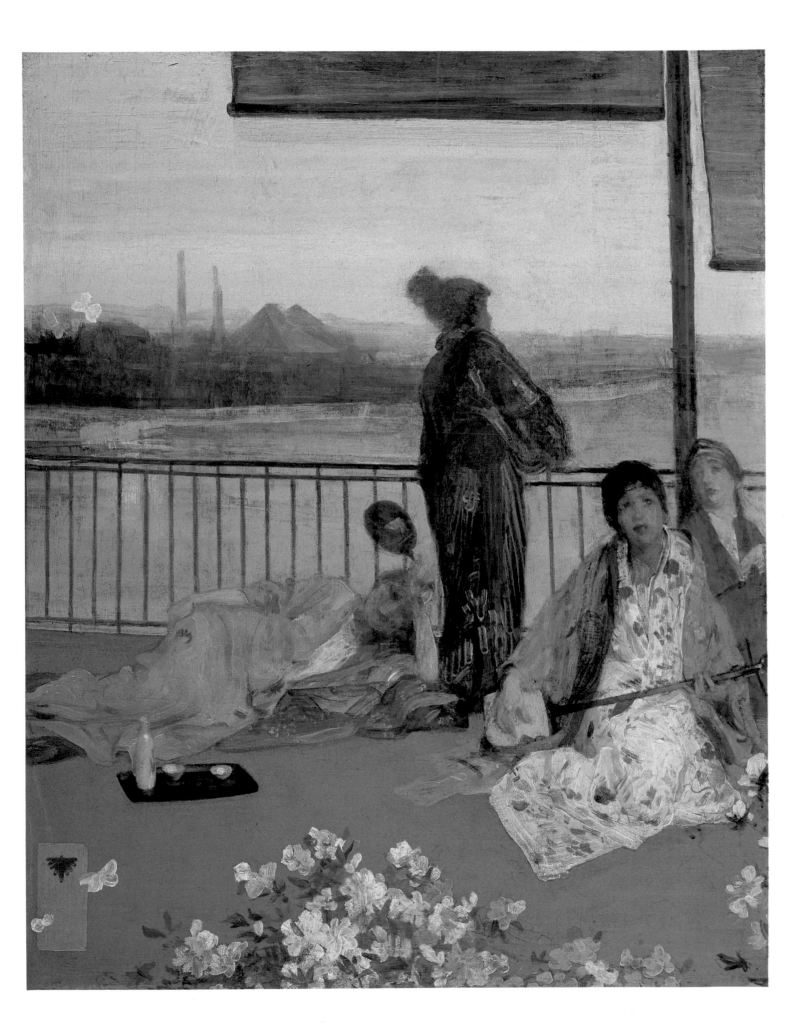

Symphony in Grey and Green: The Ocean

1866. Oil on canvas, 80.7 x 101.9 cm. Frick Collection, New York, NY

In 1866 Whistler made the surprising decision to visit South America in order to take part in the war being fought by Chile and Peru against Spain. On arrival at Valparaiso in Chile he saw little more than a skirmish when the Spanish fleet opened fire on the town, and his immediate response was to ride out of the town as fast as his horse could carry him. But if personal troubles rather than principled commitment motivated his travels, he was able to experience afresh in front of the ocean a sense of broadening horizons. The foliage and butterfly signature were added at a later date, as if to prick this vision of the infinite with a reminder of the here and now.

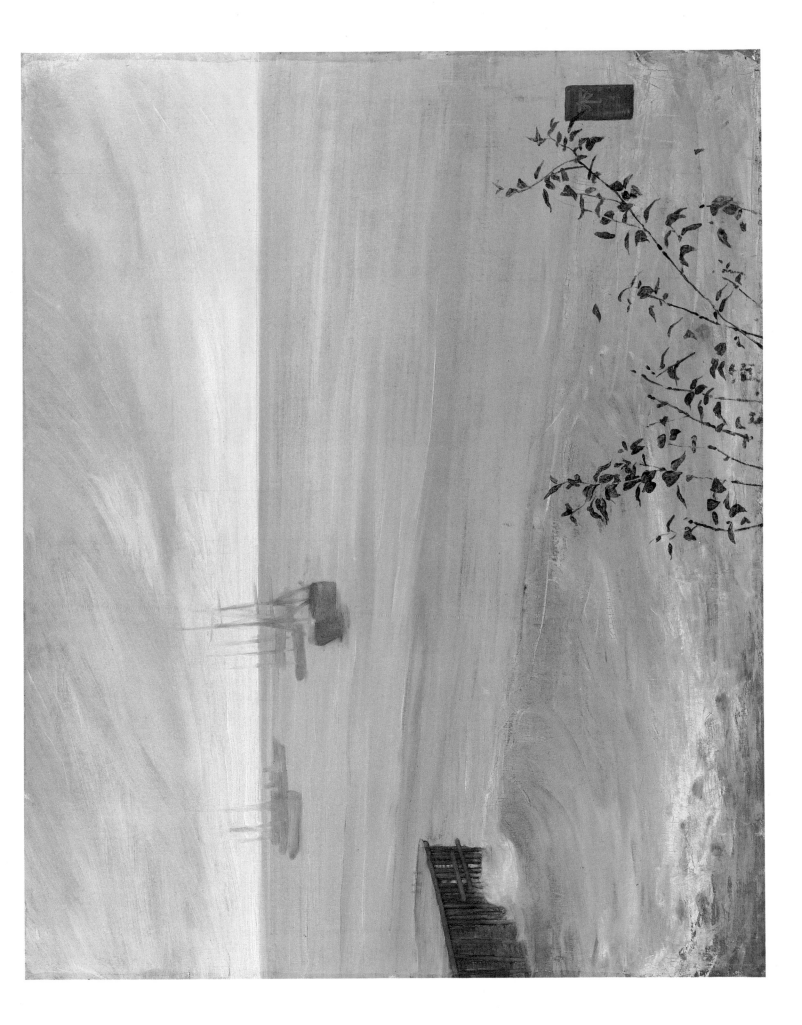

Crepuscule in Flesh Colour and Green: Valparaiso

1866. Oil on canvas, 58.4 x 75,5 cm. Tate Gallery, London

Whistler is said to have completed this painting at one sitting, having prepared his colours beforehand in readiness for the approach of dusk. Though not enough land is visible to allow for precise identification of the locality, the view is almost certainly the pool at Valparaiso where Whistler spent most of his South American visit in 1866. Painting on a warm ground, Whistler used liquid sweeps of the brush and allowed the lip of paint to create cloud-like streaks in the sky. Pencil drawing on the right-hand side can be seen under and in places over the paint. This speedy notation suggests the urgency with which he worked in his attempt to catch the dusky tones, the movement of ships and the fading light. The slight tilt of the line of the ocean invites the eye into the picture. At the same time the faint ripples in the water create movement which, paradoxically, heighten the impression of stillness, of a moment caught, hovering beween night and day.

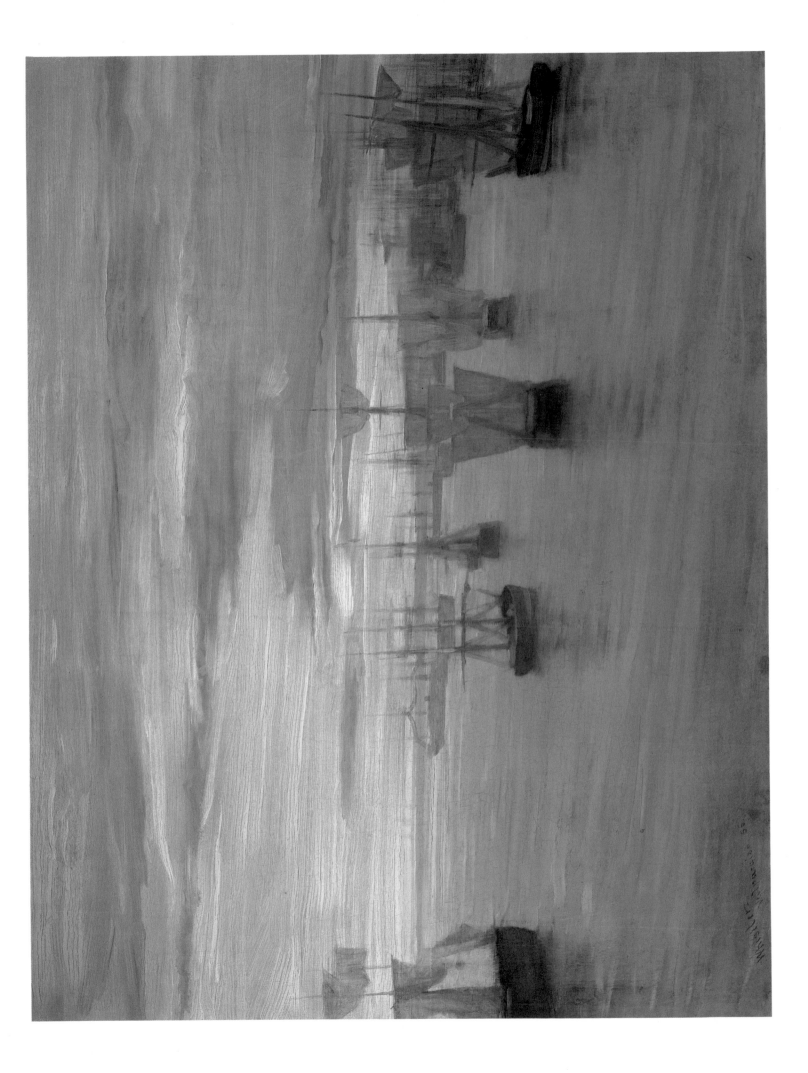

1867. Oil on canvas, 52 x 76.5 cm. Barber Institute of Fine Arts, University of Birmingham, Birmingham

Commentators on Whistler have drawn attention to the resemblance this work bears to the art of Albert Moore. The two artists met in 1865 and appear to have influenced each other, Moore adopting Whistler's use of pale colours and restricted space, Whistler learning from Moore's purely decorative subjects and his fondness for loose, elegant draperies.

This was the first painting which Whistler exhibited with a musical title, taking his cue from Paul Mantz's comment on his first 'White Girl' (Plate 7) that it represented a 'symphony in white'. But though the poses of the two women (Jo and Milly Jones, the wife of an actor), the fan and flowers intruding on the right have been arranged in accordance with the aesthetic needs of the picture, the decision to turn the gaze of one woman outwards, so that she interrogates the spectator, charges the picture with a note of psychological inquiry.

If this painting is compared with Moore's *Beads* (Fig. 30), one of a series of three paintings begun at around this date, it can be seen that Whistler took from Moore his languorous subject matter and decorative use of draperies, and Moore took from Whistler his light palette, use of planar simplification and Japanese motifs. But there the similarities end. Moore fills every corner of his carefully considered canvas with a formal richness, dense and seductive; Whistler, on the other hand, works with less, employing more subtle colour and insisting on softer and more fluid brushwork.

Fig. 30
ALBERT MOORE
Beads
*c*1875. Oil on panel,
29.8 x 51.4 cm.
National Gallery of
Scotland, Edinburgh

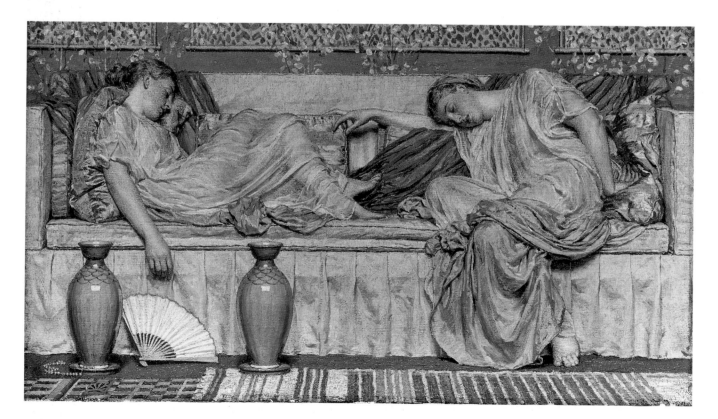

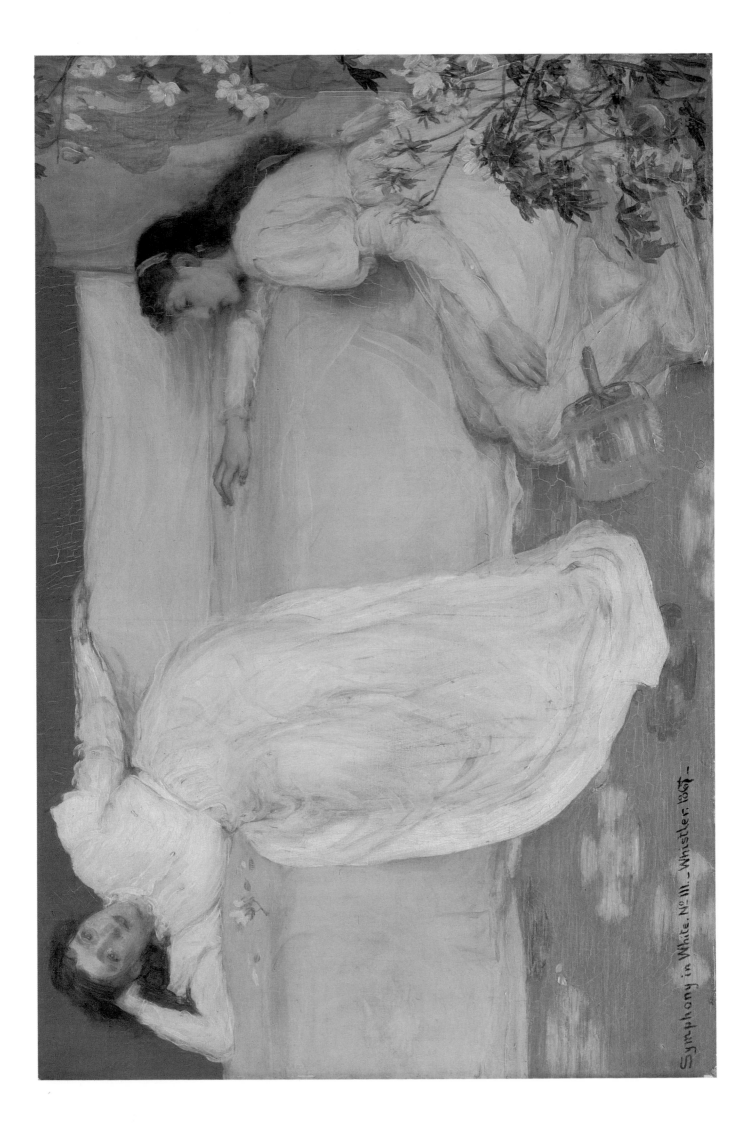

Symphony in White. N° III._ Whistler. 1867._

1868. Oil on millboard, mounted on wood, 46.9 x 61.8 cm.
Freer Gallery of Art, Washington DC

Certain ingredients in this painting stem from Whistler's admiration for Japanese prints: the light palette, for example, and the use of planar simplification. The fans also denote a touch of *japonisme*, but most striking of all are the flowing draperies which display Whistler's admiration, shared with his friend Albert Moore, for the Elgin Marbles in the British Museum. Moore's paintings of classically-draped women (Fig. 31) had alerted Whistler to the decorative role of figures arranged in a frieze across the picture surface. Whistler executed a series of paintings in this manner, pursuing purely aesthetic values, the pictures having no meaning other than the beauty they create.

Fig. 31
ALBERT MOORE
Dreamers
1882. Oil on canvas,
68.5 x 119.4 cm.
Birmingham Museum and
Art Gallery, Birmingham

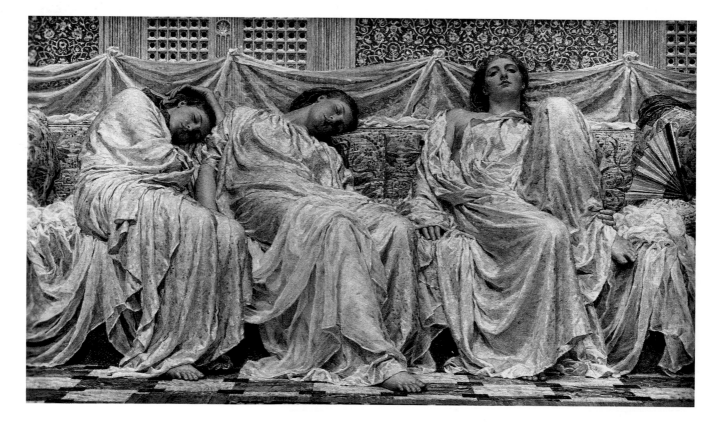

Late 1860s. Oil on canvas, 76 x 51 cm. Hunterian Museum and Art Gallery, University of Glasgow, Glasgow

This is a curious, hybrid picture within Whistler's *œuvre*. It blends his interest in misty or nocturnal river scenes with his love of a frieze-like arrangement of draped female figures. Those in the foreground recall the figures used in his Greco-Japanese oil sketches of the late 1860s, such as *The White Symphony: Three Girls* (Fig. 32). Signs of repainting suggest that at a slightly later date he repainted the three figures on the right and gave them Victorian costume. Despite this alteration the picture retains its ethereal mood.

Fig. 32
The White
Symphony: Three
Girls
*c*1868. Oil on panel,
46.4 x 61.6 cm.
Freer Gallery of Art,
Washington DC

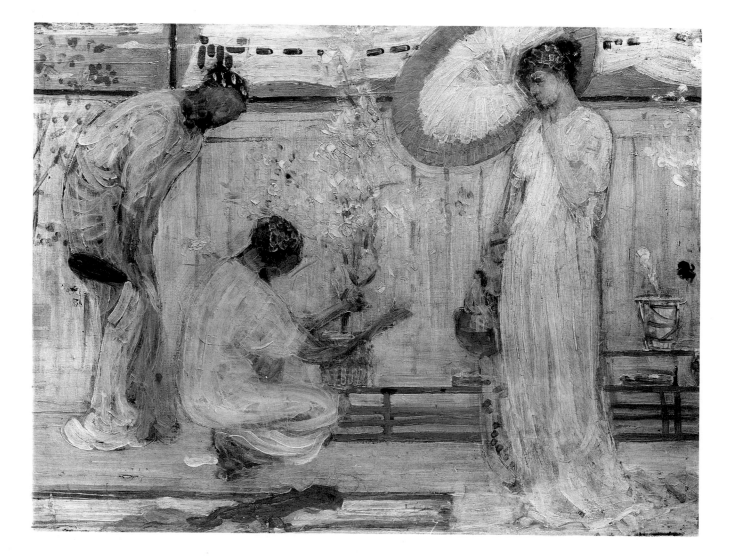

*c*1870. Oil on millboard, mounted on wood, 46.7 x 61.9 cm.
Freer Gallery of Art, Washington DC

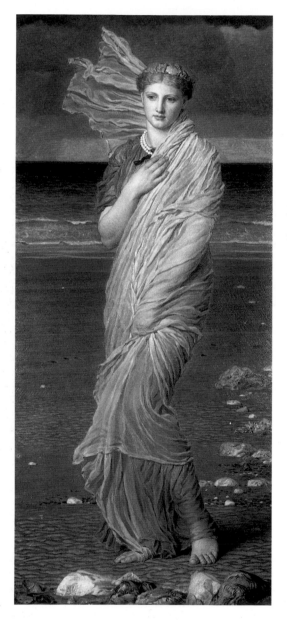

Fig. 33
ALBERT MOORE
Sea Shells
*c*1870. Oil on canvas,
157.5 x 70 cm.
Walker Art Gallery,
Liverpool

One of the 'Six Projects', a series of figure paintings in which Whistler
tried to combine Japanese and Greek influence. They are said to have
been originally intended as a decorative scheme for his patron Frederick
Leyland. Whistler may have intended to enlarge these sketches for the
final decorative scheme which never came into existence. The remaining
oil sketches did, however, at one time hang on the lemon-yellow walls of
Whistler's dining-room. While working on these paintings Whistler
worried that in subject-matter they came too close to the work of Albert
Moore who had been commissioned by Leyland to produce a pair of
pictures each showing the single figure of a woman with wind-blown
draperies on the seashore (Fig. 33). He was assured by their mutual friend,
the architect W E Nesfield, that their work was 'so very wide apart' that
any similarity in subject would not matter. The most striking aspect of
Whistler's work is his desire for effects at *premier coup*, a very direct and
fluid handling of the paint.

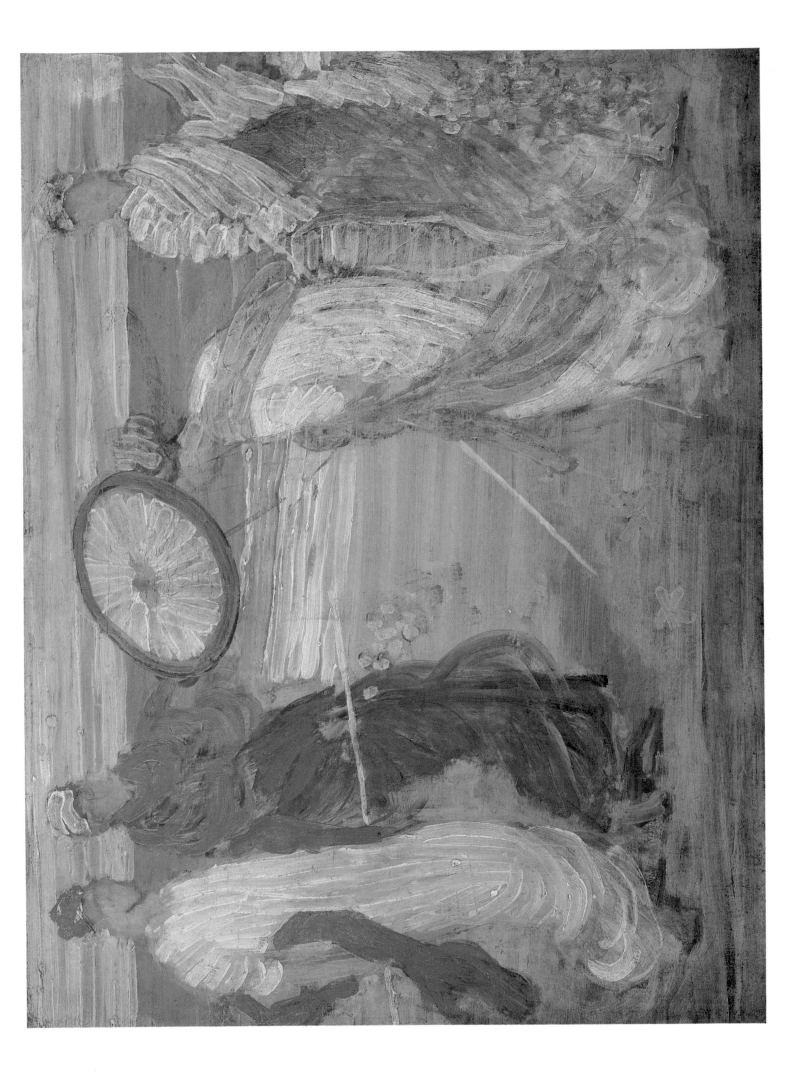

1870. Oil on canvas, 192.8 x 91.9 cm. Freer Gallery of Art, Washington DC

Fig. 34
Speke Hall
1870. Etching,
22.5 x 15 cm.
Walker Art Gallery,
Liverpool

Commissioned by the sitter, this portrait was painted at his home Speke Hall (Fig. 34), near Liverpool, in August 1870. Leyland found the sittings trying enough to refer to them as his 'martyrdom'. A ship owner with an intelligent interest in art, he collected Renaissance art as well as that of the Pre-Raphaelites. He owned not only Speke Hall but also 49 Princes Gate in London where he was to commission Whistler to design a whole room in order to display his collection of blue and white china. An able pianist and a man of considerable discernment, he entertained lavishly though he was not easy to get on with. He married Frances Dawson in 1855 but they separated in 1879.

Whistler had great difficulty in establishing the exact position of the legs and feet in this portrait and got a well known Italian model to pose nude for the figure. He went on painting in and rubbing out the figure for a year and a half, but felt confident in the end that he had arrived at a fine work.

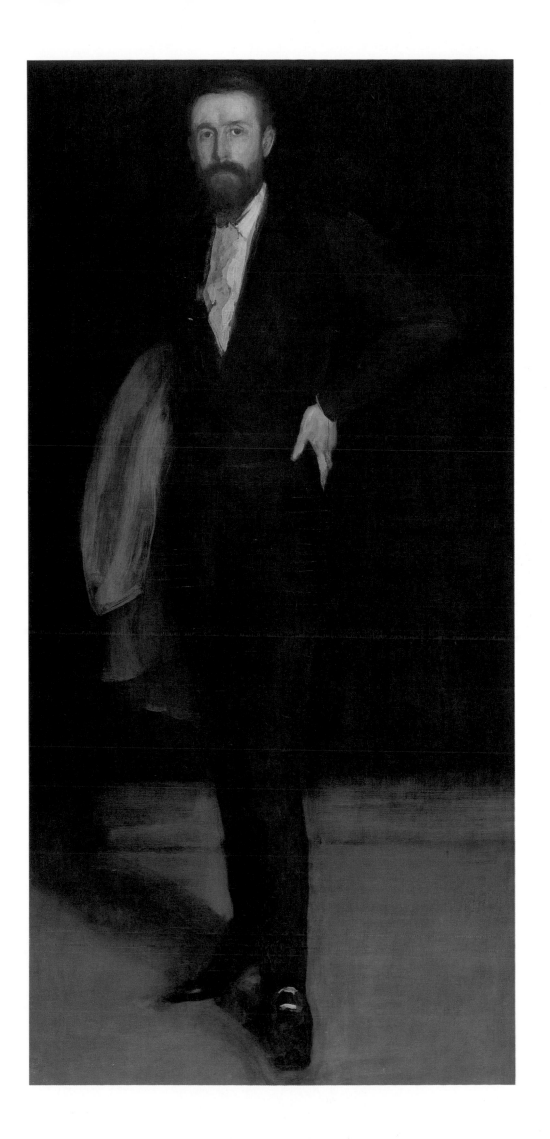

Symphony in Flesh Colour and Pink: Portrait of Mrs Frances Leyland

1871–3. Oil on canvas, 195.9 x 102.2 cm. Frick Collection, New York, NY

Begun at Speke Hall, the Leylands' home near Liverpool, this picture was finished in London. Mrs Leyland wanted to pose in black, but Whistler designed a dress he thought would be in harmony with her red hair. Drawings exist which show a more elaborate dress than is seen here but as he worked towards the final portrait Whistler simplified his ideas. As with the portrait of her husband, Whistler repeatedly rubbed down this portrait and began again, keeping his paint fluid and for the most part very thin. Despite the numerous sittings supplied by this willing subject, Whistler had again to call in a professional model to pose for the draperies. He also made an etching of her daughter, Fanny (Fig. 35).

Fig. 35
Fanny Leyland
c1872. Drypoint,
196 x 32 cm. Freer Gallery
of Art, Washington DC

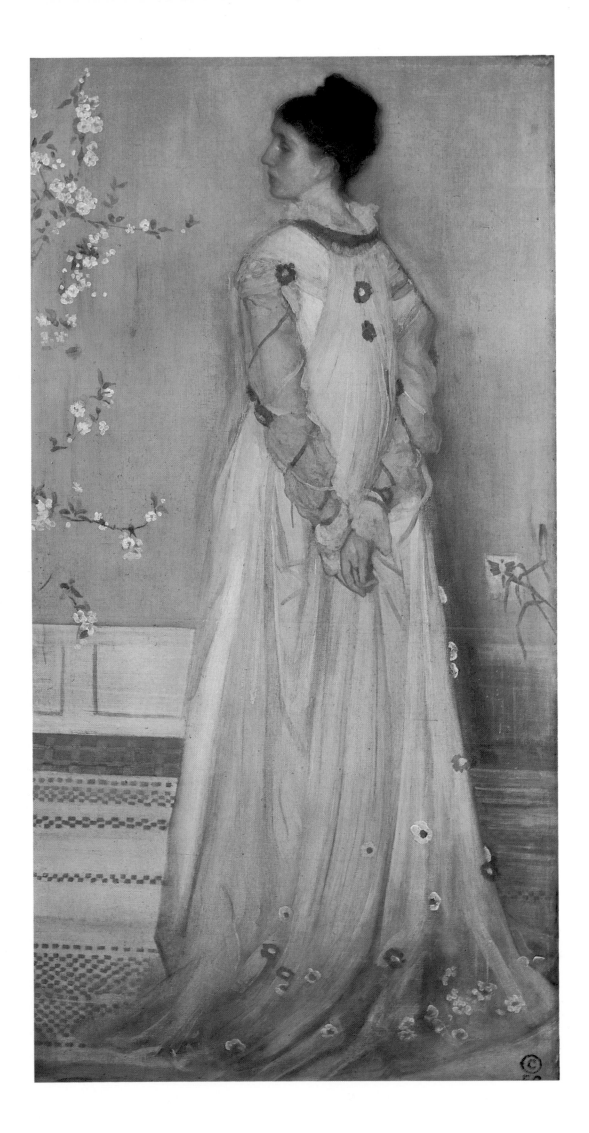

*c*1871. Oil on canvas, 45.7 x 67.5 cm. Freer Gallery of Art, Washington DC

This is again the view across river from Lindsey Row, looking towards Battersea Reach. The dull light on the water gives a limpid effect of half-light. The picture as a whole shows how Whistler could fill an empty scene with poignancy and beauty solely through his handling of paint and tone. It is possible that this picture is the one he submitted to the Royal Academy in 1872, which his mother described as 'a lovely grey dawn Study of the River'. It was presumably rejected by the Academy as no such work appeared in the annual Summer Exhibition. An early morning subject is in keeping with the mood of this picture which conveys an impression of stillness and slowly unfurling light. His response to temporal conditions can also be seen in *Chelsea in Ice* (Fig. 36). The exact date of this work is unknown, but it may have been painted in 1864 when, as his mother recorded, he spent two days painting ice flows on the Thames seated at an open window.

Fig. 36
Chelsea in Ice
*c*1864. Oil on canvas,
44.7 x 61 cm.
Private collection

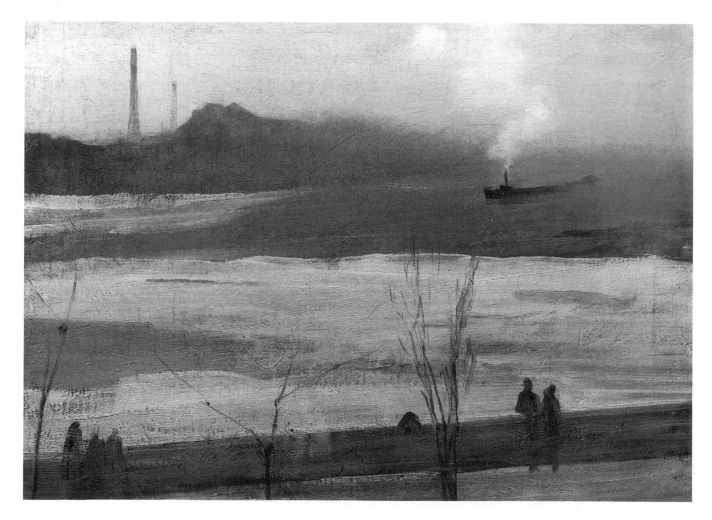

Nocturne in Blue and Green

1871. Oil on canvas, 50 x 59.3 cm. Tate Gallery, London

According to Whistler's mother, he painted this picture one evening during the summer of 1871, following a trip they had both made up the river. They had returned at dusk, the river glowing transparently in the half-light, and Whistler on reaching his house had rushed straight up to his studio, his mother helping to find the tubes of paint he needed. The view is that seen from Battersea of the Chelsea shore with the tower of Old Chelsea Church in the distance. It was Whistler's habit in his 'Nocturnes' to use a dark warm ground, the red or brown paint forcing up the blues and greens. He also by now developed the technique of using long ribbons of fluid paint which, when dragged from one side of the canvas to the other, give a feeling of space and movement. Within the monochromatic palette, the gradations of tone are extremely subtle and the positioning of the few select details – the barge, the figure of a mud-lark and the stabbing verticals created by the reflections of the lights – is intensely calculated. Nothing disturbs the richly poetic atmosphere.

Arrangement in Grey and Black No. 1: The Artist's Mother

1871. Oil on canvas, 144.3 x 162.5 cm. Musée d'Orsay, Paris

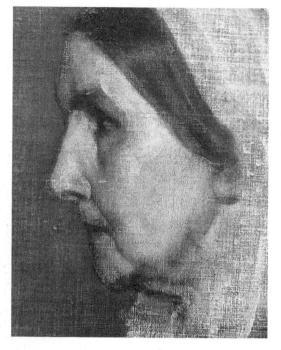

Fig. 37
Detail of Plate 29

Whistler's fondness and respect for his mother had led him in early manhood to exchange his middle name 'Abbott' for her maiden name 'McNeill'. He had first conceived of painting her portrait in 1867 but did not finally do so until the summer of 1871 while Anna Mathilda Whistler was staying with him at Lindsey Row. She originally posed in a standing position, but, owing to a recent illness, found this too tiring, and after two or three days the seated pose was begun. The sitter's inner quietness made her an admirable subject and Whistler, painting only for himself, depended less on his nerves but allowed no lessening of his desire for perfection. He achieved his results with the most limited means, the paint in places merely staining the canvas, the transparency of the head-dress suggested by thinly-scumbled paint (Fig. 37), the delicate, uneven grey-green on the wall behind achieved by use of glazes and the whole brought to life by the dancing pattern of lines and dots, a kind of visual fugue, on the curtain to the left of the figure.

Various sources have been suggested for the pose, but the originality that Whistler brought to his conception of it caused a great many other artists to experiment with the seated side-view. One of the first reviews of this painting mentioned the artist's powerful intellectual grasp of the Protestant character. Another critic suggested: 'An artist who could deal with large masses so grandly might have shown a little less severity, and thrown in a few details of a interest without offence.' This drew from Whistler the stinging comment that suitable details might be 'a glass of sherry and the Bible!' To another he remarked, with teasing understatement: 'Yes – one does like to make one's Mummy just as nice as possible!' He refused to sell the painting but eventually accepted an offer for it from the French Government. In keeping with the sitter's deep religious convictions, the portrait exudes a mood of great devotion.

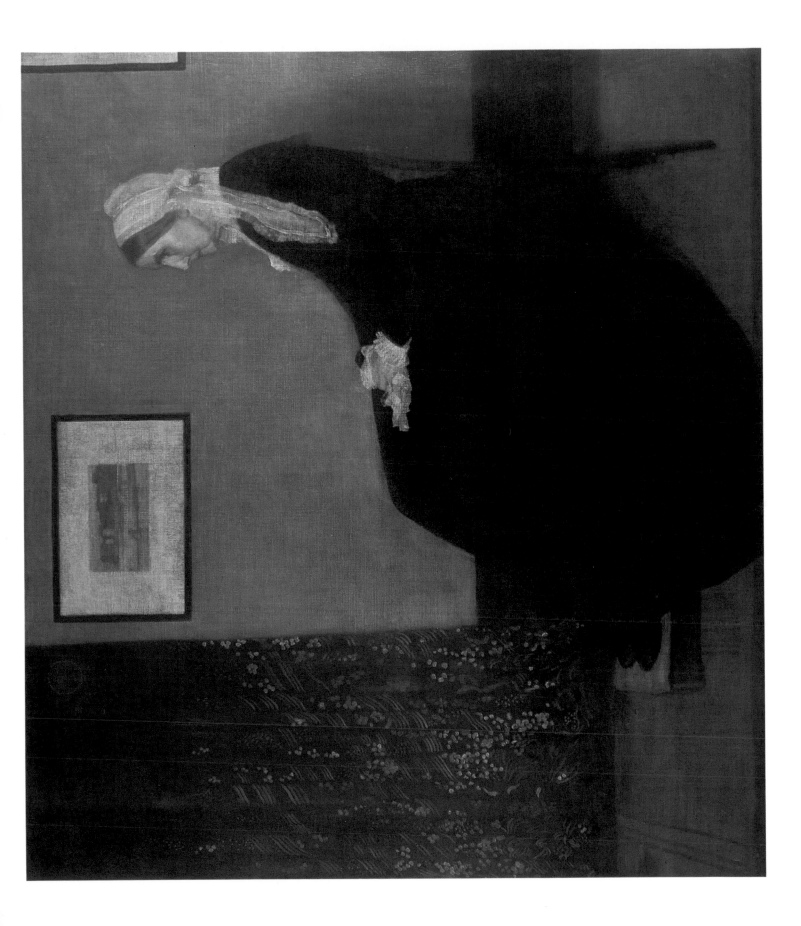

1872. Oil on canvas, 74.9 x 53.3 cm. Detroit Institute of Arts, Detroit, MI

Whistler first exhibited this painting in 1872, the year in which he also began his portrait of Carlyle. Both portraits make use of a skilful arrangement of the parts. The charm of this more informal, less studiously composed work lies in the apparent facility with which the artist has caught a breathing likeness of himself. His handling varies across the picture: the yellow-grey background is laid down with vertical strokes of the brush, the face is more carefully and fluidly modelled, while the jacket is only very roughly shaped with large sweeps of paint. The result, as Whistler himself said, is 'a fine portrait by me of myself, life sketch'.

His biographers, the Pennells, thought it the first portrait to show his lock of white hair which he trained upwards like a feather. When in 1895 the painting changed hands and its new owner asked Whistler to sign it, he refused, explaining that the butterfly was his signature.

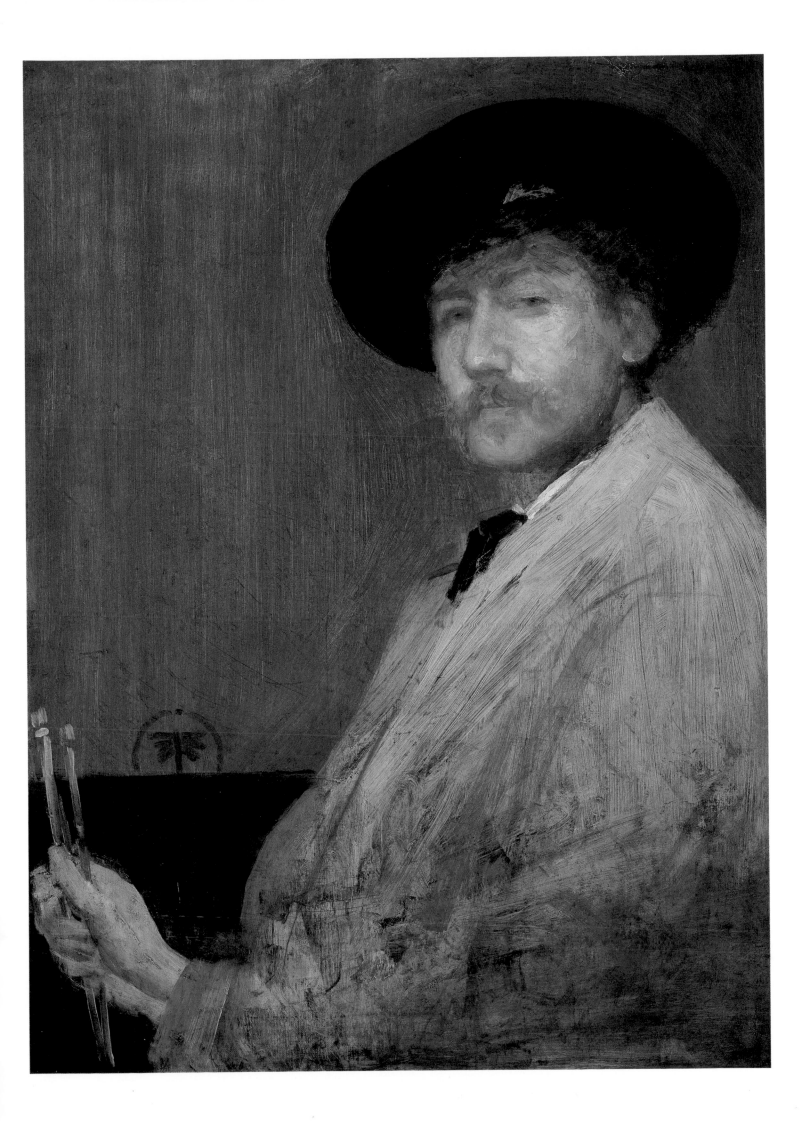

Arrangement in Grey and Black No. 2: Portrait of Thomas Carlyle

1872. Oil on canvas, 171 x 143.5 cm. City Art Gallery, Glasgow

According to Whistler, Carlyle was persuaded to sit for his portrait after he saw that of the artist's mother in Whistler's studio in 1872. He was by this stage in his life a sad, sombre and often very silent man, and Whistler has caught both his dignity and his weariness of spirit. The sittings took place in Whistler's studio at 2 Lindsey Row which had grey walls and a black dado. Having originally asked for two or three sittings, Whistler achieved many more until Carlyle rebelled, observing that the artist was paying more attention to his coat than his face. He did however grant that Whistler had given him clean linen.

It is doubtful if Whistler had read much of Carlyle's colossal output; perhaps he knew of his comparison of the spiritual faith of his day with that of the Middle Ages in *Past and Present* and of his weariness of the age in which he lived. A familiar figure in Chelsea, Carlyle had converted his attic in Cheyne Row into a double-walled garret to keep out the noise of 'dogs, cocks, pianofortes and insipid men'.

From *pentimenti* (mistakes which have been overpainted) it is possible to see the many alterations Whistler made to Carlyle's back, hands, hat and coat, until he found the exact solution he wanted. 'He is a favourite of mine,' Whistler wrote of this portrait in 1891. 'I like the gentle sadness about him! – perhaps he was even sensitive – and even misunderstood – who knows!' When he sat for this portrait he had been a widower for eight years and was described during those last years of his life as 'gloomily serious', an old man 'gazing into the final chasm of things'. His attitude of mind is well summed up in his reply to the villager who remarked that it was a fine day – 'Tell me something, mon, I dinna ken.'

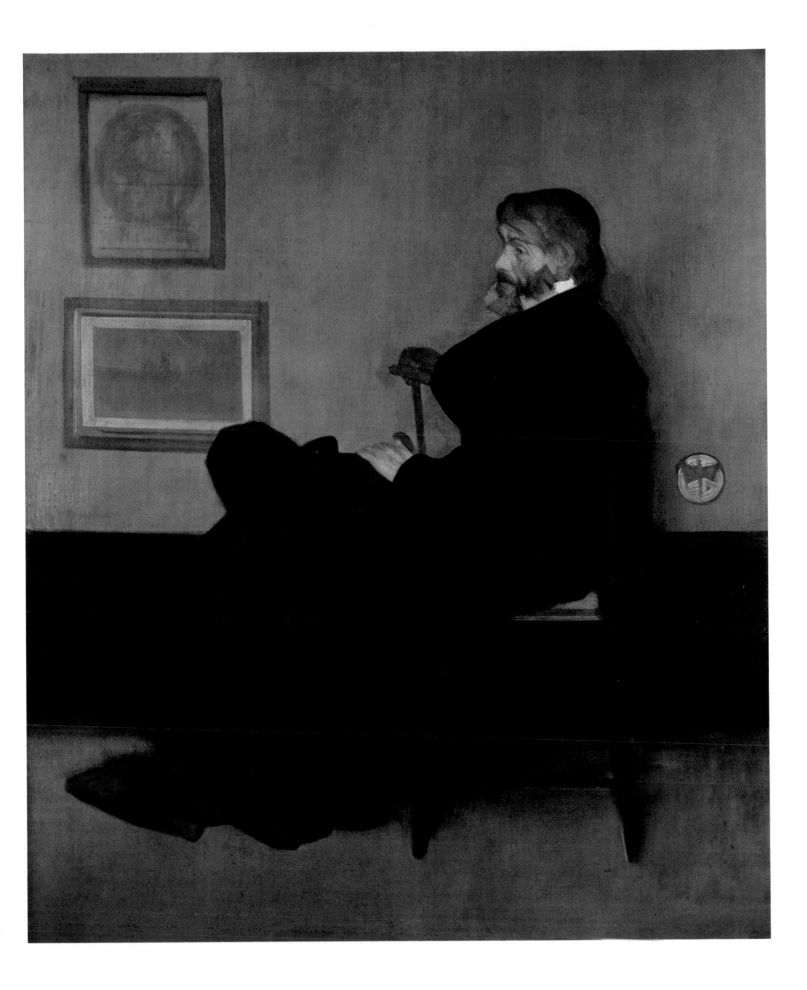

1872. Oil on canvas, 50.2 x 74.9 cm. Tate Gallery, London

The critic of the *Athenaeum* commented in 1882 that in this picture Whistler had rendered 'with exquisite gradations and perfect truth' the effect of an early morning mist on the Thames. 'Pallid azure vapours fill the vista just before dawn. On the shores are gleams of orange light. With much skill a drifting raft, giving due solidity to the whole, has been placed in front.'

Neither the title, nor anything that Whistler wrote or said, confirms the notion that this picture represents an early morning scene rather than dusk. It does, however, show his fascination with a time of day at which the half-light blends the outlines of distant buildings into one mass. As the colour drains away, a sense of mystery envelops an everyday scene.

33

Nocturne: Blue and Gold – Old Battersea Bridge

1872/3. Oil on canvas, 66.6 x 50.2 cm. Tate Gallery, London

Whistler seems to have taken his starting point for this 'Nocturne', perhaps the most famous of all of them, from the Japanese artist Hiroshige in a number of whose prints the composition is dominated by the curve of a bridge. Certainly this is the most Oriental of all Whistler's 'Nocturnes'. The dark mass of the bridge echoes the verticals and horizontals in the picture's format and thereby heightens the tension between our awareness of the flatness of the picture plane and the suggestion of pictorial space. In contrast with the bulk of the bridge Whistler has speckled the sky with golden sparks left by a rocket, their brief efflorescence underlining the mood of transience.

The subtle change in tone from one side of the bridge to the other helps suggest distance. The eye is also invited in through the faint rippling of water in the foreground. A single note of red warms the composition, while in the foreground the bent figure of the bargeman gives it human scale. It is thought that Walter Greaves may have encouraged Whistler in his choice of subject for this picture.

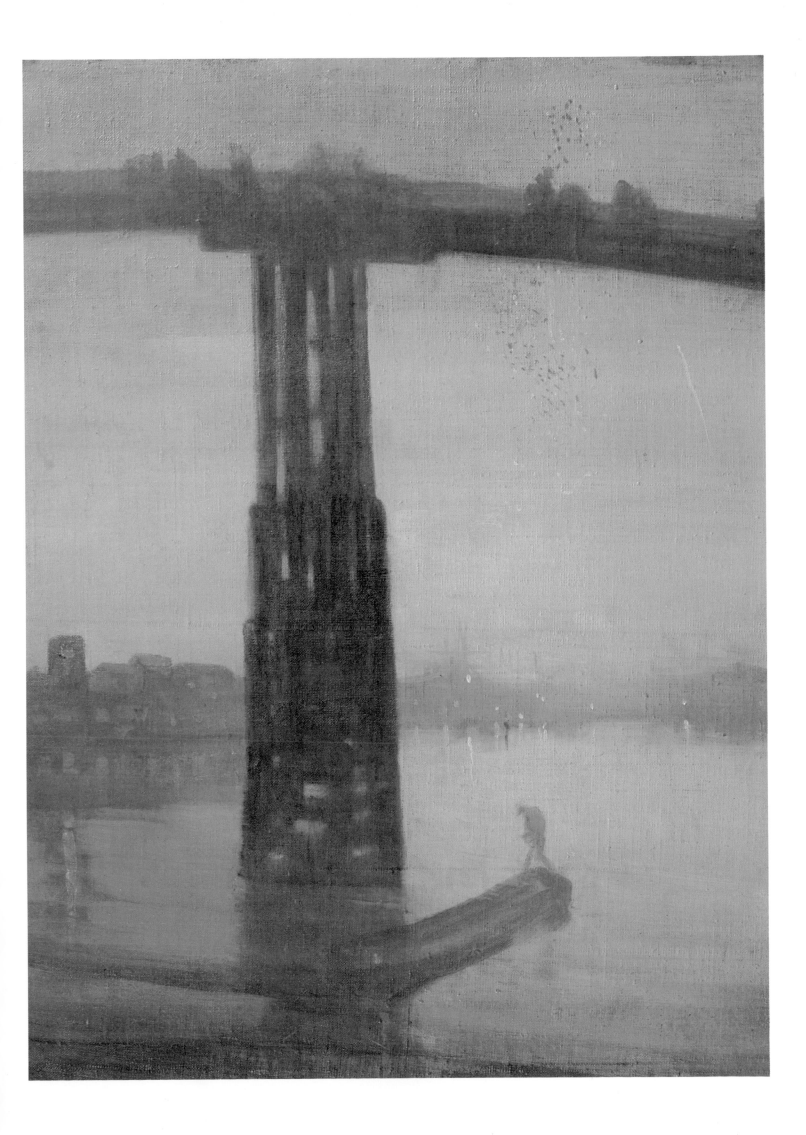

Harmony in Grey and Green:
Miss Cicely Alexander

1872–4. Oil on canvas, 190 x 98 cm. Tate Gallery, London

Cicely Alexander was the daughter of a London banker and collector. When this portrait was commissioned in 1872 the sitter was eight years old. In the course of the many sittings Whistler never allowed the young girl to change her pose. The sitter remembered being 'a very grumbling, disagreeable little girl', but the length of the sittings and Whistler's capacity to forget about meals make this understandable. He recommended to her mother the style of dress the young girl should wear, even going so far as to advise on the choice of material and where it could be obtained. He also suggested the use of a little starch to make the frills and skirt stand out.

A similar perfectionism determined the final picture where the position of every detail is finely judged and every tone weighed and balanced in relation to the whole. The pair of butterflies in the top left add to the poise of the whole by creating an imaginary diagonal in relation to the head and the daisies which pull against the directional movement of the pose.

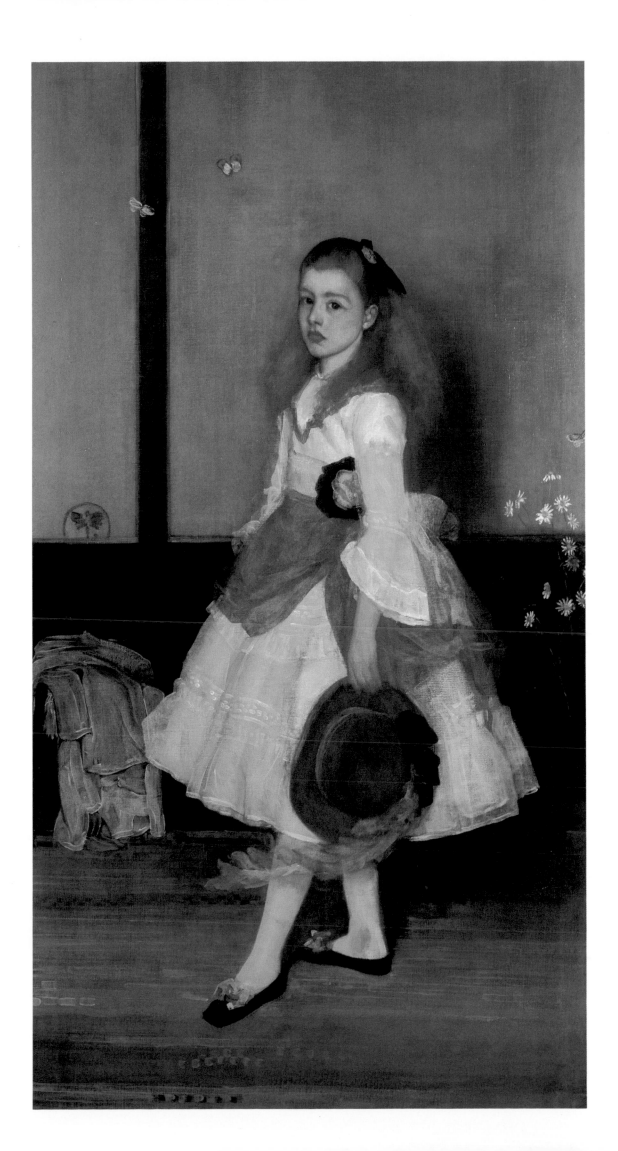

Cremorne Gardens, No. 2

*c*1872/7. Oil on canvas, 68.5 x 135.5 cm. Metropolitan Museum of Art, New York, NY

Cremorne Gardens were a pleasurable haunt on the Chelsea Embankment, associated with firework displays as well as prostitutes. Whistler based six of his nocturnal paintings on these gardens. He found it easy under the lamps in the gardens to put down what he needed in black and white chalk on brown paper. A similar nonchalance is conveyed here by the figures as they promenade.

Whistler's introduction to Cremorne Gardens came though the Greaves family, new neighbours of his in Lindsey Row, Chelsea. The father built and rented boats and his two sons often rowed Whistler up the river at night. They also painted, Walter Greaves especially developing a style that more and more imitated that of Whistler. His early work, however, shows a more realistic grasp of the river life with which he was intimately acquainted (Fig. 38).

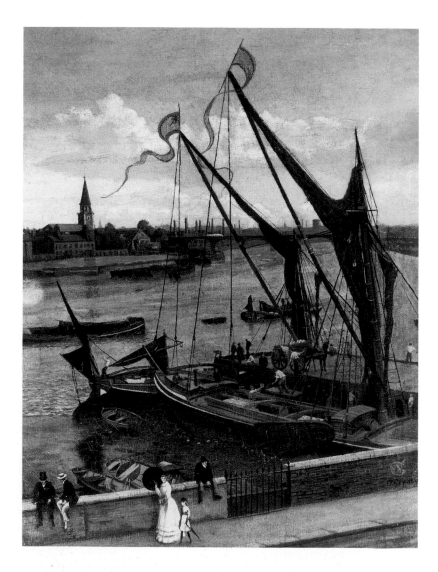

Fig. 38
WALTER GREAVES
Unloading the Barge:
Lindsey Quay and
Battersea Church
*c*1860. Oil on canvas,
61 x 45.7 cm.
Kensington and Chelsea
Library, London

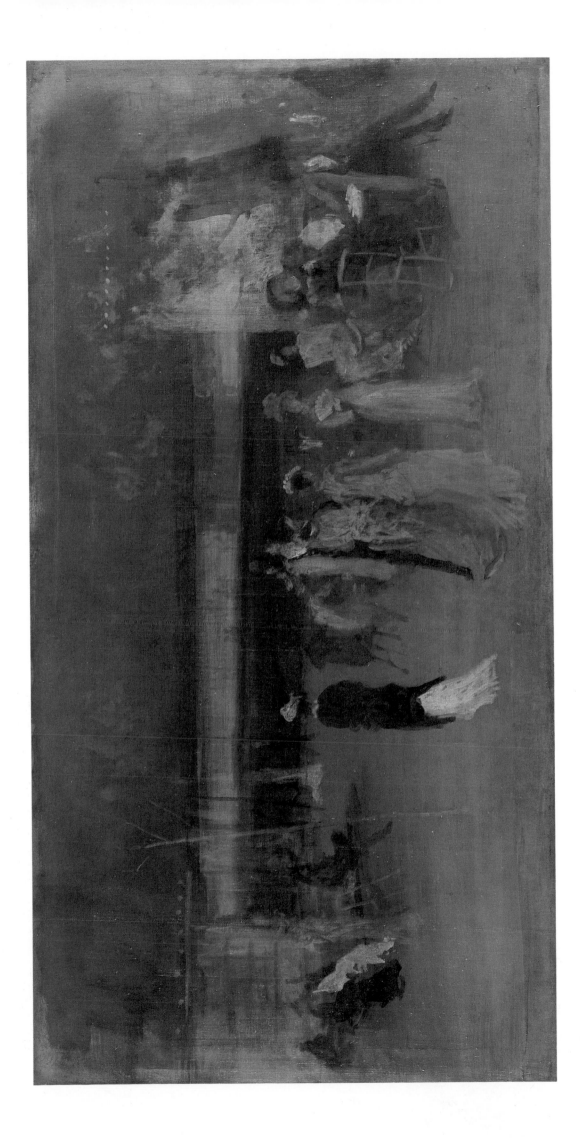

Nocturne in Black and Gold: The Falling Rocket

1875. Oil on wood, 60.3 x 46.6 cm. Detroit Institute of Arts, Detroit, MI

Fig. 39
The Interior of the
Grosvenor Gallery
from the *Illustrated London
News*, vol. LXXX, 1877

This is one of the eight pictures which Whistler showed at the opening exhibition of the Grosvenor Gallery (Fig. 39) in the summer of 1877. It caught Ruskin's eye and became the focus of his criticism of all that Whistler stood for in aesthetic terms. When Whistler read Ruskin's opinions, he regarded them as libellous. Ruskin had compared the work of Sir Edward Burne-Jones (1833–1898) ('wrought with the utmost conscience of care') with Whistler's impudence in asking 200 guineas 'for flinging a pot of paint in the public's face'. As this was the only work in the Grosvenor Gallery exhibition which Whistler had priced at 200 guineas, he assumed it was to this picture that Ruskin referred. Under cross-examination during the trial, heard in November 1878, Whistler said that the picture represented a distant view of Cremorne Gardens, with a falling rocket and other fireworks. It had taken him two days to paint, was conscientiously accomplished and worth the price asked. When showing the picture to the artist Sydney Starr (1857–1925), Whistler commented: 'It's the finest thing that ever was done. Critics pitch into it. But bring tots, idiots, imbeciles, blind men, children, anything but Englishmen or Ruskin, here, and of course they know – even you.'

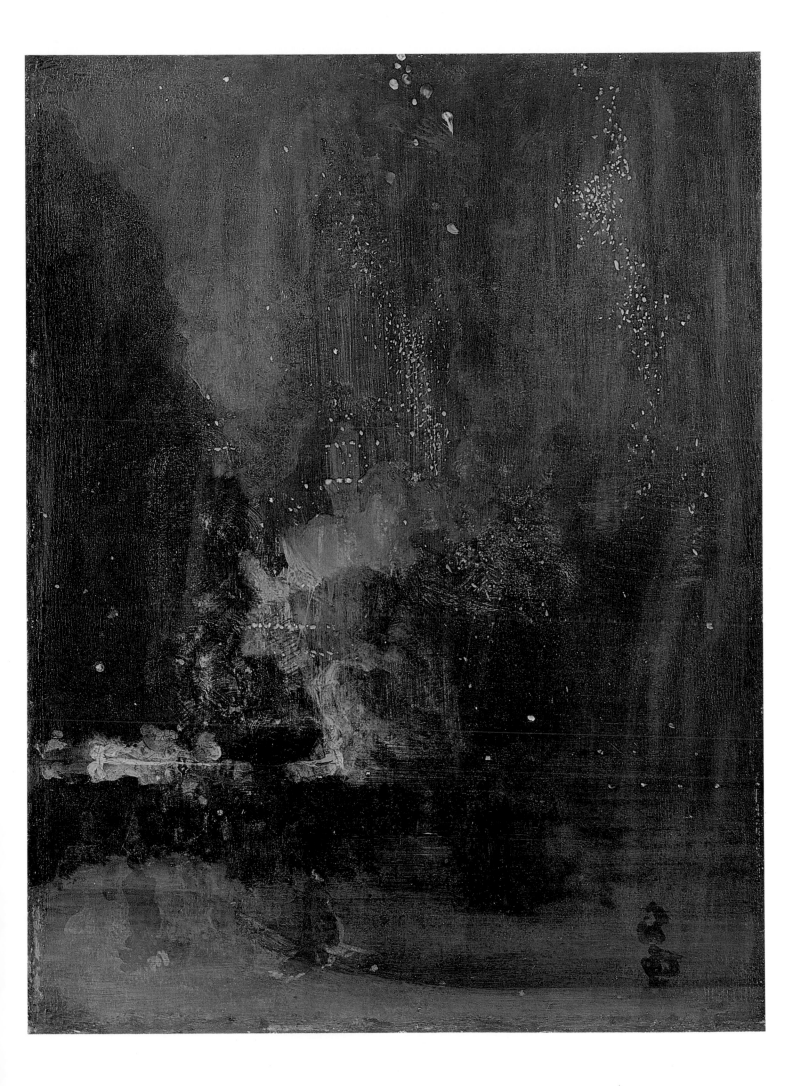

Arrangement in Brown and Black: Portrait of Miss Rosa Corder

*c*1876. Oil on canvas, 192.4 x 92,4 cm. Frick Collection, New York, NY

Whistler got the idea for this picture after seeing Rosa Corder in a brown dress pass a black door. The sitter told the artist and memoirist Graham Robertson that she posed standing in a doorway with the darkess of a shuttered room beyond. She gave about 40 sittings, some of which lasted until she fainted. She eventually refused to go on with them. Rosa Corder was herself an artist and learned etching from Whistler. For a time she had a studio at Newmarket and painted racehorses. She also painted portraits, including one of F R Leyland. Graham Robertson's own memory of Rosa Corder conflicts with Whistler's picture: 'Her hair was a curious pale brown...and she was gentle and crushed-looking...the Whistler picture...makes her proud and stately.'

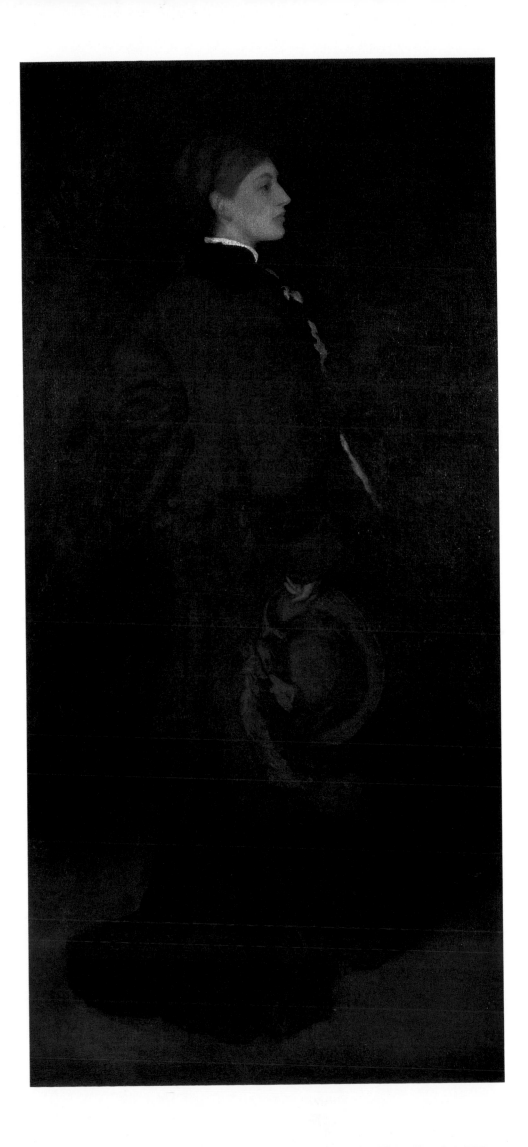

Harmony in Blue and Gold: The Peacock Room

1876–7. Oil and gold leaf on leather and wood, 425.8 x 1010.9 x 608.3 cm.
Freer Gallery of Art, Washington DC

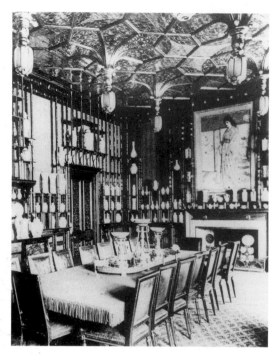

Fig. 40
The Peacock Room,
Princes Gate, showing
*La Princesse du pays de
la porcelaine* and the
blue and white china
on the shelves
1892. Photograph.
University of Glasgow
Library, Glasgow

F R Leyland employed the architect Norman Shaw to direct the reconstruction of his London house, 49 Princes Gate, and asked Thomas Jeckyll, another architect whose most notable achievement seems to have been a pair of wrought iron gates, now at Sandringham, Norfolk, to adapt the dining-room so that it would house his collection of porcelain. In April 1876 Jeckyll consulted Whistler on colours for the doors and windows. Whistler, noticing the old Spanish leather with which Jeckyll had covered the walls, observed that the red flowers which patterned it, as well as the carpet, clashed with the colours in his picture, *La Princesse du pays de la porcelaine* (Plate 12), which hung in the same room. Leyland gave Whistler permission to retouch the leather and make other small alterations. No contract, however, was drawn up and when Leyland was called back to Liverpool on business Whistler assumed control of the whole room. He not only painted the entire room a deep blue, but also added designs of peacocks to the window shutters and picked up the motif of the eye and breast feather in decorative waves around the walls. The idea grew as Whistler painted. When the room was finished (Fig. 40), and without first obtaining its owner's permission, he held a Press view in the house at which he distributed a pamphlet, *Harmony in Blue and Gold: The Peacock Room*. Whistler's conceit over his achievement with this room was so great that when later he visited St Mark's in Venice, with its elaborate gold mosaics, he could not help feeling that the Peacock Room had the edge on it with regard to beauty of effect.

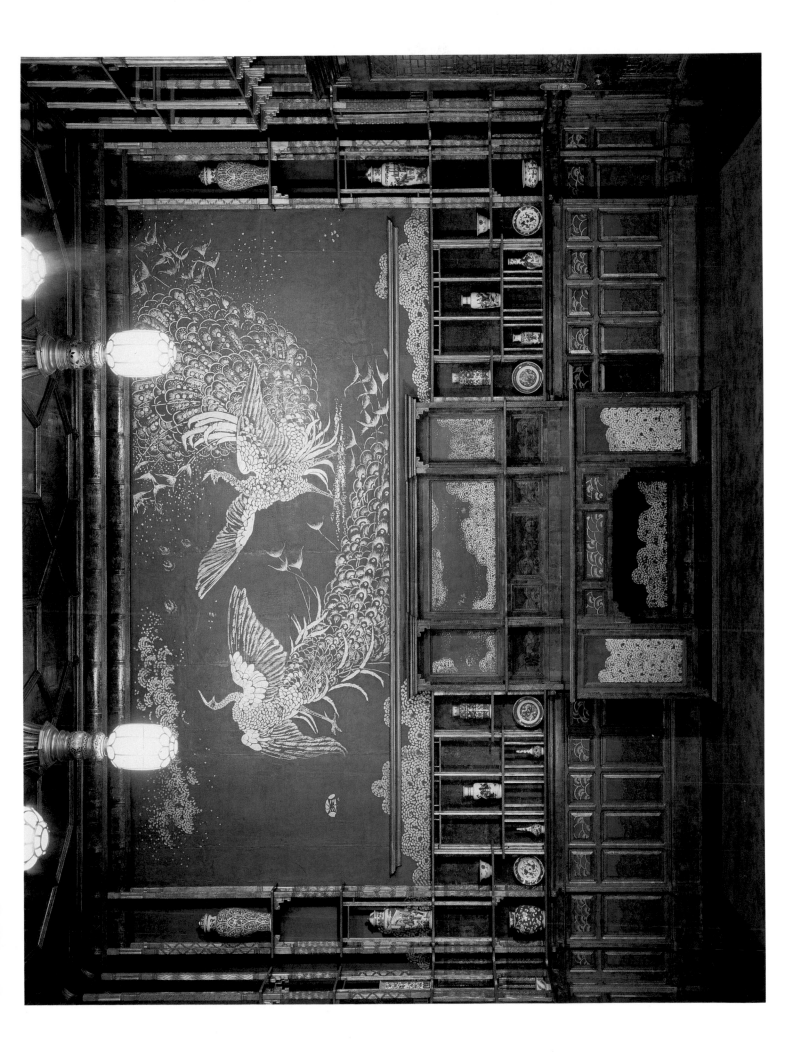

Nocturne in Blue and Silver:
The Lagoon, Venice

1879/80. Oil on canvas, 51 x 66 cm. Museum of Fine Arts, Boston, MA

Whistler painted very few pictures in Venice, concentrating more on etching. Those that were done, it is claimed, were mostly painted from memory. The extreme smoothness of this 'Nocturne' may have been achieved by rubbing the canvas after it was painted, in this way blurring the shapes of figures, gondolas and the tall ship resting in the water on the left. The first owner of this painting is thought to have been Whistler's model Carmen Rossi who was suspected of stealing drawings and paintings from his studio. He never took action against her, though he attempted to do so against the dealers who bought work from her.

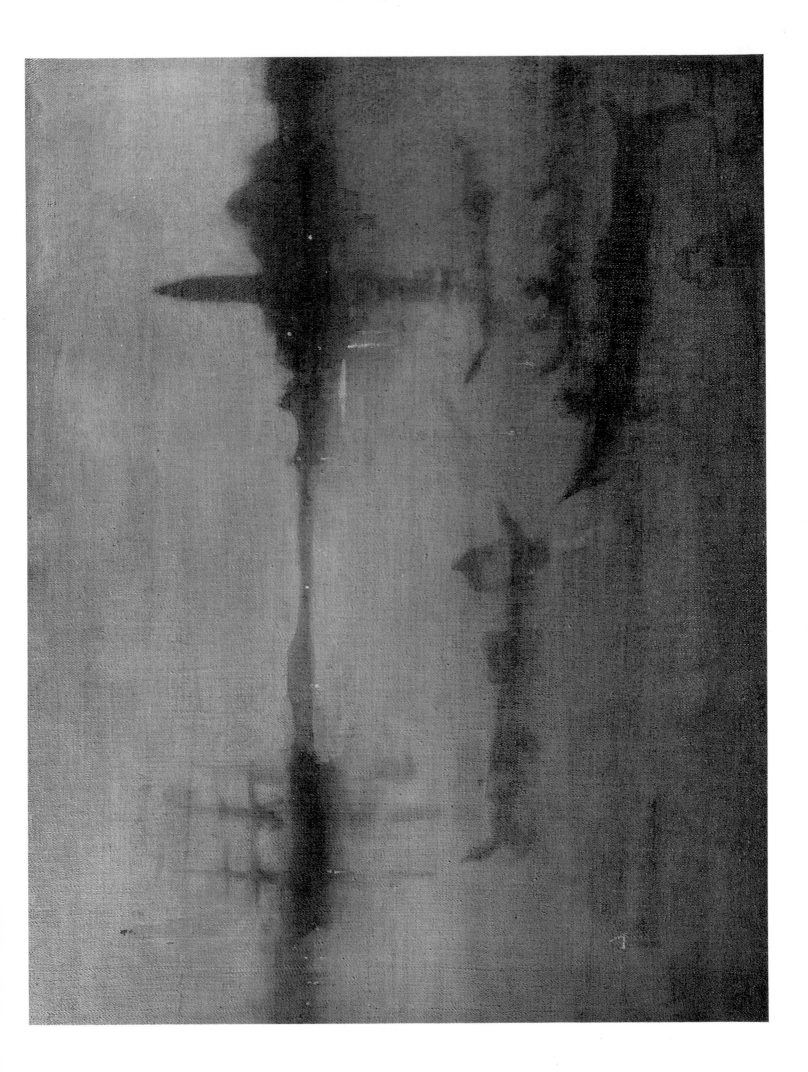

Arrangement in Flesh Colour and Black: Portrait of Théodore Duret

1883–4. Oil on canvas, 193.4 x 90.8 cm. Metropolitan Museum of Art, New York, NY

The decision to paint this portrait was made one evening while Duret was dining at Whistler's house. The two men had earlier visited an exhibition together and were discussing the pictures they had seen. Whistler took offence at a portrait in which a president of a society or corporation had been shown wearing an antique costume which conflicted with his contemporary hairstyle. They went on to discuss what would be original yet familiar dress in a modern portrait. Whistler wondered why evening dress, in which English gentlemen of the period spent a good part of their life, was so rarely seen in portraiture. After a moment's reflection he asked Duret to pose for him in evening dress, asking him also to bring a pink domino. The request for a cloak surprised Duret but he found what was needed at a theatrical costumier in Covent Garden, and on the appointed day arrived at Whistler's house dressed accordingly.

Duret, an art critic and connoisseur, owned several of Whistler's paintings and published a monograph on him as well as influential articles. The black of Duret's suit is hardly modelled at all, but the incisive outline gives weight and body to the figure. When showing visitors this portrait in his Paris apartment Duret would take a sheet of paper, cut a hole in it, and hold it against the grey background, to prove that the grey, when surrounded by white, and not warmed by nearby colours, is pure and cold, untouched by rose. He did this to prove Whistler's knowledge of the effect of colours in relation to each other and his mastery of tone. When Duret decided to sell this portrait to a museum in 1909 he approached the Metropolitan Museum of Art in New York. Roger Fry was then its European adviser and Duret told him that Whistler had taken three months to paint this picture, 'allowing each *couche* to dry thoroughly. Consequently there is no cracking or dragging at all.'

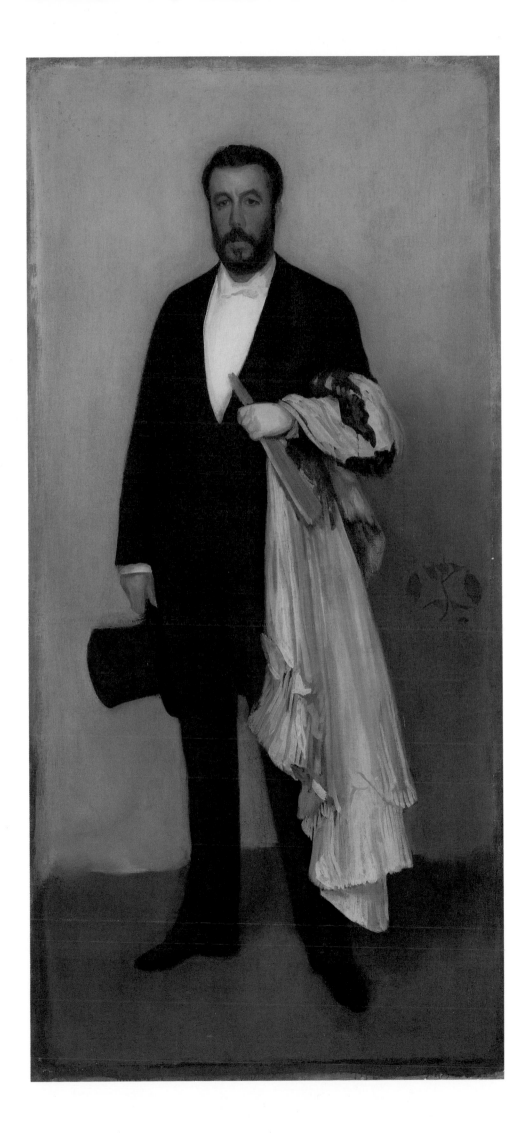

Grey and Silver: Mist – Lifeboat

1884. Oil on wood, 12.3 x 21.6 cm. Freer Gallery of Art, Washington DC

The small size of this work and its subject-matter make it almost certainly one of the oil panels Whistler painted at St Ives early in 1884. Later that year it was exhibited in both London and Dublin. It demonstrates beautifully Whistler's marrying of his technique with his subject, the deftness of his touch evoking the lapping movement of the water. The dark accents created by the boats at sea, the two foreground figures and the butterfly monogram occupy one side of the picture, an arrangement that ought to make the composition lopsided. What prevents this from happening is the directional movement of the lifeboat which carries the eye forward across the empty stretch of water. The small touch of red on the lifeboat is echoed in one woman's shawl and, still more faintly, in the butterfly – another instance of Whistler using his monogram to contribute to the design and harmony of the whole.

A Shop

1884/90. Oil on canvas, 13.9 x 23.3 cm. Hunterian Museum and Art Gallery, University of Glasgow, Glasgow

In his *Ten O'Clock Lecture*, delivered in 1885, Whistler defined one aim of the artist as 'seeking and finding the beautiful in all conditions and in all times'. In the 1880s he spent much of his time working on a small scale, either in watercolour or in oil on small wooden panels. His two followers at this time were the artists Walter Sickert and Mortimer Menpes. The latter's fascination with Whistler is apparent in his art which adopts Whistler's style, and in the etching which captures his vivacity (Fig. 41). Menpes recounted how responsive Whistler was to small visual incidents in the streets around him: 'It might be a fish shop with eels for sale at so much a plate, and a few soiled children in the foreground: or perhaps a sweet shop, and the children standing with their faces glued to the pane.'

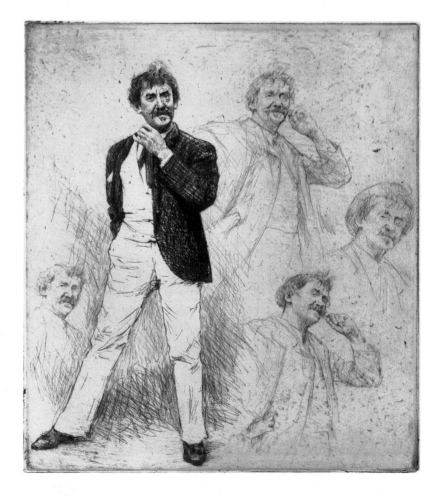

Fig. 41
MORTIMER MENPES
Whistler: Five Studies
1880s. Drypoint,
17.5 x 15.1 cm.
New York Public Library,
New York, NY

An Orange Note: Sweet Shop

1884. Oil on wood, 12.2 x 21.5 cm. Freer Gallery of Art, Washington DC

Painted at St Ives early in 1884, this picture received much notice when exhibited later the same year. The critic in the *Artist* wrote of 'a doorway, a tiny shop window piled with oranges and cakes, a shelf full of bottles containing lollipops, and three little figures'. The *Standard* said of it: 'It is without detail, without apparent labour, without dramatic interest, but it is exquisite in colour, faultless in tone, and its well considered mystery has, at least, the interest of suggestiveness.'

Many of the small pictures that Whistler produced in his later years were, like this one, executed on wood panel and were of a size that could be packed away in a paint box. On his painting expeditions in the 1880s he was often accompanied by followers and pupils, among them Walter Sickert and Mortimer Menpes, both of whom at this time imitated his interest in carefully selected arrangements of tone and hue (Fig. 42).

Fig. 42
WALTER SICKERT
The Red Shop or the October Sun
*c*1888. Oil on panel, 26.7 x 35.6 cm.
Castle Museum, Norwich

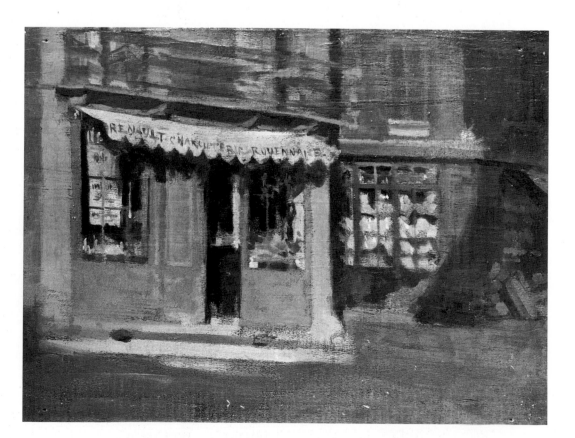

*c*1880–7. Oil on wood, 13.3 x 23.5 cm. Stanford University Museum and Art Gallery, Stanford, CA

Fig. 43
Gold and Orange:
The Neighbours
1880s. Oil on panel,
21.6 x 12.8 cm.
Freer Gallery of Art,
Washington DC

This picture is another instance of Whistler's capacity to distill compositional interest from an ordinary street scene. The paired doors find an echo in the two figures on the left. It is typical of Whistler that the human presence should be suggested in a lighter fashion than the architecture, but it is also likely that these two figures, painted very thinly, have become more faint with time. A similar brevity of notation can be found in *Gold and Orange: The Neighbours* (Fig. 43).

In his *Ten O'Clock Lecture*, delivered in 1885, Whistler encouraged artists to find beauty in their everyday surroundings. He did so in the streets of Chelsea, no less than in the canals of Venice.

Harmony in Red: Lamplight

1886. Oil on canvas, 190.5 x 89.7 cm. Hunterian Museum and Art Gallery, University of Glasgow, Glasgow

The sitter for this portrait was Beatrice Godwin, daughter of the sculptor John Birnie Philip, who was married to the architect E W Godwin. She was posing for Whistler at the time of Godwin's death and continued to do so. When another of his sitters cancelled Whistler wrote to her: 'Do...come over to the studio at once...and we may run right through with it this morning! – we can darken the place and turn the gas.' Two years earlier Whistler had moved to 454 Fulham Road where he had a kind of chandelier of argand burners whose yellowish light altered the appearance of colours with interesting effect. Mrs Godwin was herself an artist and a collection of her work exists in the Hunterian Museum and Art Gallery, Glasgow. She married Whistler on 14 August 1888. Her death from cancer on 10 May 1896 left him utterly distraught.

46 Harmony in Blue and Gold: The Little Blue Girl

1894–1901. Oil on canvas, 74.7 x 50,5 cm. Freer Gallery of Art, Washington DC

Whistler first showed an interest in painting the female nude when producing his 'Six Projects' in the late 1860s. One of these showed a Venus standing at the edge of the sea with her cloak billowing out behind her. In this work he returns to the same theme, contrasting a naked figure against drapery and deliberately using a dim tonality in order to prevent the pale body from creating too great a contrast with its surroundings. Compared with the relaxed drawing and flamboyant brushwork of his 'Six Projects', this picture has a tightness of design and execution which adds to the stillness of the whole. The white jug, the lines of the bench and those of the balustrade help frame and position the figure but do not prevent her from looking frail and vulnerable.

The Little Rose of Lyme Regis

1895. Oil on canvas, 51.4 x 31.1 cm. Museum of Fine Arts, Boston, MA

During a visit to Lyme Regis in 1895 Whistler suffered a period of doubt about his work, particularly his lifelong desire to attain completeness in his work in one final *coup*. He now admitted 'time is an element in the making of pictures' and produced work in which the glowing colour is the product not of a single layer of paint but the slow layering of glazes. He produced several small portraits of children around this time, capturing them with a tenderness that never becomes sentimental. The sitter for this was Rosie Randall, daughter of the Mayor of Lyme Regis.

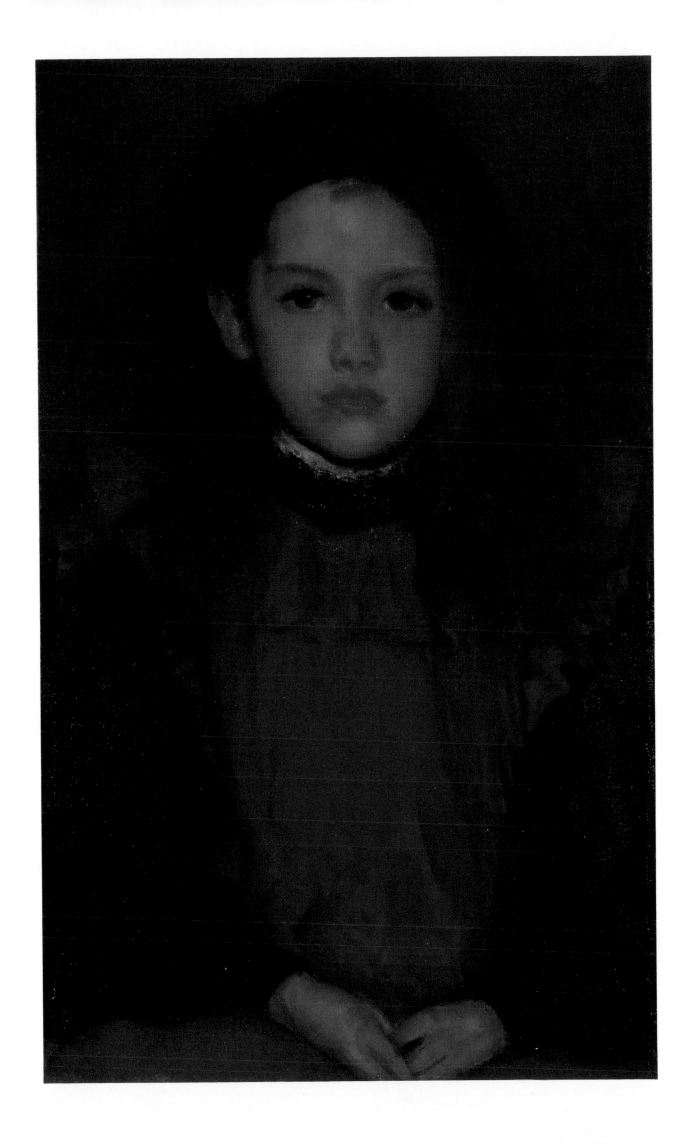

1895. Oil on canvas, 51.4 x 31.1 cm. Museum of Fine Arts, Boston, MA

Built up with overlapping layers of paint, this picture has an engaging reality, a great confidence similar to that which the blacksmith himself seems to convey. Whistler had completed all the preliminary stages for this painting during his stay at Lyme Regis in 1895, but, as he told the New York dealer E G Kennedy, he kept hold of this picture for a while afterwards adding 'precious touches'. Aware of its quality, he initially thought of asking between 600 and 800 guineas, but when it was completed, in September 1896, Kennedy agreed to pay £1,500 for it. Despite the price he received, Whistler was still loath to part with the picture and took it round to show his biographers, the Pennells, before it left for America.

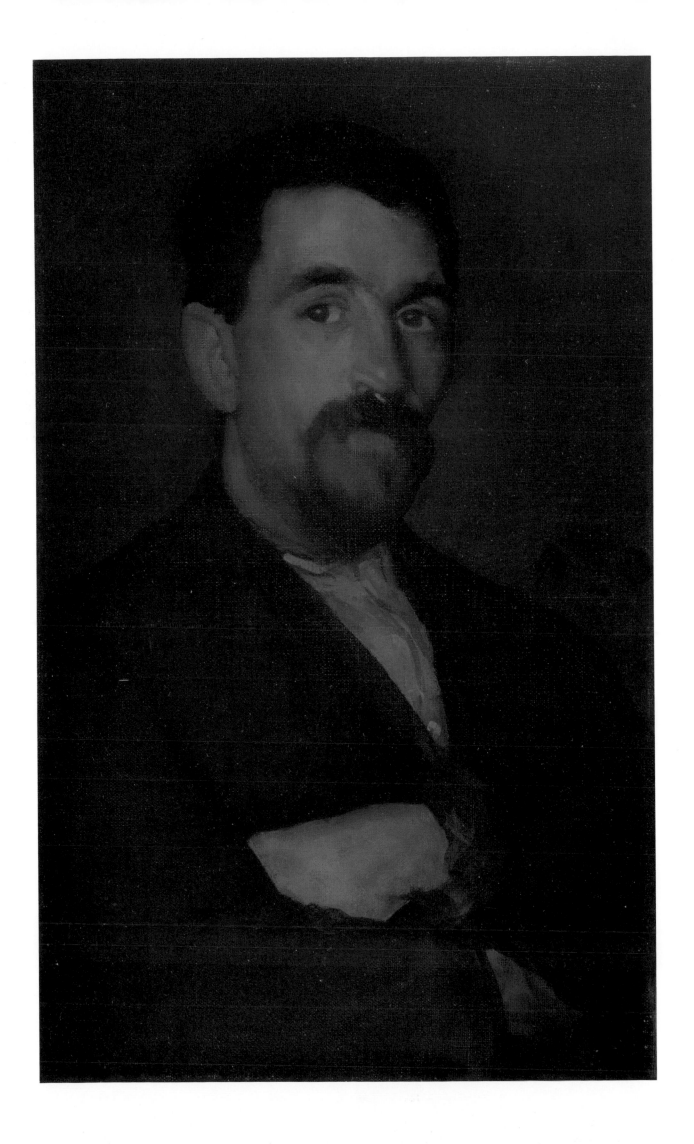

PHAIDON COLOUR LIBRARY
Titles in the series

FRA ANGELICO
Christopher Lloyd

BONNARD
Julian Bell

BRUEGEL
Keith Roberts

CANALETTO
Christopher Baker

CARAVAGGIO
Timothy
Wilson-Smith

CEZANNE
Catherine Dean

CHAGALL
Gill Polonsky

CHARDIN
Gabriel Naughton

CONSTABLE
John Sunderland

CUBISM
Philip Cooper

DALÍ
Christopher Masters

DEGAS
Keith Roberts

DÜRER
Martin Bailey

DUTCH PAINTING
Christopher Brown

ERNST
Ian Turpin

GAINSBOROUGH
Nicola Kalinsky

GAUGUIN
Alan Bowness

GOYA
Enriqueta Harris

HOLBEIN
Helen Langdon

IMPRESSIONISM
Mark Powell-Jones

**ITALIAN
RENAISSANCE
PAINTING**
Sara Elliott

**JAPANESE
COLOUR PRINTS**
J. Hillier

KLEE
Douglas Hall

KLIMT
Catherine Dean

MAGRITTE
Richard Calvocoressi

MANET
John Richardson

MATISSE
Nicholas Watkins

MODIGLIANI
Douglas Hall

MONET
John House

MUNCH
John Boulton Smith

PICASSO
Roland Penrose

PISSARRO
Christopher Lloyd

POP ART
Jamie James

**THE PRE-
RAPHAELITES**
Andrea Rose

REMBRANDT
Michael Kitson

RENOIR
William Gaunt

ROSSETTI
David Rodgers

SCHIELE
Christopher Short

SISLEY
Richard Shone

**SURREALIST
PAINTING**
Simon Wilson

**TOULOUSE-
LAUTREC**
Edward Lucie-Smith

TURNER
William Gaunt

VAN GOGH
Wilhelm Uhde

VERMEER
Martin Bailey

WHISTLER
Frances Spalding

2 2 DEC 2010

XMAS

This book should be returned/renewed by
the latest date shown above. Overdue items
incur charges which prevent self-service
renewals. Please contact the library.

Wandsworth Libraries
24 hour Renewal Hotline
01159 293388
www.wandsworth.gov.uk Wandsworth

THE BRIGHTER BOROUGH

L.749A (2.07)

KT-431-180

This story is dedicated to my brother Gerry and my parents, in memory of all
the great Christmases we had together.

ACKNOWLEDGEMENTS
I've tried to keep the list short, and hope I don't offend anyone if I leave them out. Firstly, my wife,
Georgina, and my daughters, Francesca and Gabriella, for putting up with me whilst creating the story.
Nicholas Kennedy for his friendship and direction. Peter Froggatt for being there when I needed a
shoulder to lean on. Phil Slattery for believing in the project (not forgetting Jane). Vanessa Chapman at
ITV for her confidence. The team at ITEL, and everyone else who has helped make my dream come true.

First published by HarperCollins *Publishers* Ltd 1997 © Text and characters Christmas Promotions Ltd 1997
© Illustrations Cosgrove Hall Films Ltd 1997
A CIP catalogue record for this book is available from the British Library.
The author asserts the moral right to be identified as the author of this work.

1 3 5 7 9 10 8 6 4 2
ISBN 0 00 664645-X

Father Christmas and the
Missing Reindeer

Geoffrey Sundquist

Collins

An Imprint of HarperCollinsPublishers

It was Christmas Eve, the day before Father Christmas had to deliver presents to every child in the world and he was in a bit of a tizz. In fact, he was so frazzled he couldn't even get his boots on properly.

He put his left boot on his right foot - and his right boot on his left foot.

'Oooh!' he gasped as he tripped up with a crash.

Father Christmas sorted himself out and went outside, still muttering, into the deep white snow. 'Here, reindeer,' he called. 'Dancer, Prancer, Cupid! I've got some tasty moss for you!' But there was no answer. No patter of big hooves, no excited snorts. Every single reindeer had gone.

Suddenly Father Christmas spotted something. Tyre tracks. Lots of them. 'But reindeer don't wear tyres,' he puzzled. Then he saw something else. Footprints. 'Someone else has been here!' he gasped. 'And they have stolen my reindeer!'

It was the worse thing that could ever happen on Christmas Eve. 'They could be anywhere in the whole world,' he said panicking, 'and I've got to find them. Because if I don't –' and he could hardly bring himself to say it – 'there'll be no Christmas!'

Just then, there was a flutter of wings and a little robin landed on his shoulder. It had a scrap of paper in its beak. 'It's a clue!' cried Father Christmas. 'But I haven't a clue what it is! Yes, yes, I know they've been stolen, Robin. But what can I do?'

He rushed indoors and there on a high shelf was his Christmas Magic Spell Book, quietly singing to itself.

As soon as it saw Father Christmas, the book jumped off the shelf into his arms. 'Slow down,' said the book. 'What's going on?'

'My reindeer have disappeared!' said Father Christmas, 'and Christmas is ruined and all the children around the world are going to be so unhappy and -'

'Calm down,' said the book. 'CALM DOWN! And try turning to page 387.'

Father Christmas started flipping the pages until he found the right page. Then he read out:

'If on Christmas Eve 'tis found
Not one reindeer's health is sound,
Then around the world you'll find your way
By cruising on the magic sleigh.

But that's not much help, book! The reindeer aren't ill, they're missing! And anyway, my sleigh isn't magic.'

'It will be,' sighed the book. 'If you repeat these words to it. It's a magic spell, don't forget. Oh, and you'll need this.' In a shower of sparkling Christmas dust appeared a magic trumpet. 'Blow on this and your reindeer will reply. But beware.'

'Beware?'

'The spell only lasts twelve hours. If you haven't found your reindeer by then you'll have to walk home.'

Father Christmas went out to his sleigh. He opened the Magic Book and read out the spell. Suddenly, his sleigh was covered with millions of glittering coloured stars.

'Wow!' gasped Father Christmas. 'It really works!'

'Of course I work,' said the sleigh.

Father Christmas gulped. 'And you can talk!'

'You notice everything, don't you?' said the sleigh, grinning. 'Now let's get going.'

Father Christmas tried to protest. 'I can't fly without reindeer!'

'But I can,' said the sleigh calmly.

They zoomed crazily into the sky. 'Careful!' yelped Father Christmas.

'Are you frightened, or something?' said the sleigh.

'No, it's just that I'm used to my own driving,' muttered Father Christmas.

'LOOK OUT!'

Simon was walking home through the park.

Suddenly, there was a flash of scarlet and silver and something hurtled past him and crashed into a snow drift.

He ran to see if he could help. An old man with a long white beard was crawling out of an upturned sleigh.

'Are you all right?' said Simon.

'Fine,' said Father Christmas, shaking the snow off his beard. 'Father Chris...I mean, Mr Nicholas at your service.'

'I'm Simon Watson,' said Simon.

'I'm looking for my reindeer,' explained Father Christmas. 'You haven't seen them, I suppose?'

'No,' said Simon, 'but I'd like to help. I'm good at finding things.'
He hopped onto the sleigh.

'H-aang on!' yelled Father Christmas as the sleigh whooshed up into the sky.

Everything turned upside down for Simon. Trees, houses, fields flashed past. It was fantastic, like the biggest roller coaster ride in the world.

'Look!' he shouted. Far below there were some animals. Were they reindeer?

'Down we go!' cried Father Christmas happily.

They landed with a bump and Father Christmas leapt out of the sleigh. 'Reindeer, it's me!' he cried. The first creature stared. Then it snorted and stamped its feet.

'Oh no! It's a bull!' yelped Simon as they ran for the sleigh.

Running back to the sleigh, Simon saw a poster on the wall for Bingly's circus. There was a corner torn off the poster and it was exactly the same size as the piece that Robin had given to Father Christmas.

'This is the clue,' gasped Simon. 'Your reindeer must have been stolen by the circus.'

'But that doesn't help us,' said Father Christmas sadly. 'The circus could be anywhere. We've only got a few hours and Christmas will be ruined.'

He sniffed hard, put his hand in his pocket for a tissue to blow his nose - and pulled out the magic trumpet that the Christmas Book had given him.

'Silly me!' beamed Father Christmas. 'I'd forgotten all about this. If the reindeer hear it, they'll let us know where they are. Blow it hard, Simon and we'll find those circus thieves!'

A cold wind whistled through the holes in the Big Top at Bingly's circus. Mr Scraggins, the evil ringmaster, was in a terrible temper.

'Are the reindeer ready yet, Wanda?' he demanded. Wanda had been born in the circus. All the animals loved her but nothing she did would cheer up these new reindeer. In fact, big fat tears rolled down their noses every time she tried to make them do a trick.

'I'm afraid not, Mr Scraggins,' admitted Wanda. 'They're lovely but they're not quite right for the circus.'

'Not right!' screeched Mr Scraggins. 'They'd better be doing tricks by tonight or you'll be sorry!'

Wanda sighed and took the reindeer out to
the field. Suddenly, their ears twitched,
their heads raised and they began to shout in
their reindeer voices. They had heard the magic
trumpet and they knew that Father Christmas was
near.

'What is it?' whispered Wanda. 'What can you hear?'

But Father Christmas had heard his reindeer. With tears
of happiness in his eyes he explained to Simon his plan to set them free.
'While I go and untie them, do you think you can creep over to the Big Top
and make a terrific noise?'

'Yes,' nodded Simon, 'but why?'

'So no one will be looking my way,' said Father Christmas, as he
clambered out of the sleigh.

Bravely, Simon crept towards the Big Top. Outside was a huge cannon and Simon grinned to himself as he lit the fuse.

'BOOM!' went the cannon.

'What's happening?' cried everyone else.

'A spy!' yelled Mr Scraggins. 'Or were you trying to get in for free?' He grabbed hold of Simon and dragged him over to an iron cage. 'Let's see what Daisy the bear has to say to boys who sneak into the circus!' Wanda watched in horror as Simon struggled desperately. 'You can't do that!' she cried. 'Daisy hasn't been fed yet!'

Father Christmas took only a few moments to find his beloved reindeer. 'Dancer! Prancer! Cupid - thank goodness you're all here!' They hurried to the sleigh. 'We're back!' cried Father Christmas. 'Simon? Where is that boy?' He turned around and what he saw made his blood run cold.

D aisy the bear had just woken up and she was towering over Simon.

'Quick!' snapped the sleigh as they shot into the air. 'We've got no time to waste.'

It was Wanda who saw them first. 'The reindeer,' she cried. 'They're flying!'

'Rubbish,' snarled Mr Scraggins. 'If this is a trick...' But it was true. The reindeer were zooming over the Big Top.

Wanda saw her chance and she dashed over to Daisy's cage.

'Daisy! This boy is my friend!' Daisy paused and stared at Simon. Gratefully, Simon slipped through the bars of the cage and jumped to the ground.

Mr Scraggins cracked his whip with rage as the reindeer dived low over his head. Then something amazing happened. The whip which the evil ringmaster used to keep power over the circus, caught on the sleigh runner and it was jerked out of his hand.

The sleigh hovered over Simon's head and he snatched the whip as it passed. Then he looked at Wanda. 'Come on! It's my turn to help you!'

He took hold of her hand and they were both swung up into the sky.

Mr Scraggins howled with rage as he saw the two children escaping; but soon he was yelling in a very different way. Daisy the bear had pushed open the door of her cage. Who had beaten her with his whip? And who didn't have his whip any longer? Mr Scraggins took one look at the angry bear and he fled.

Father Christmas smiled at Wanda. 'Where can we take you?' he asked.

'I want to stay with the circus,' said Wanda. 'I don't think we need to worry about Mr Scraggins any longer.' She added, 'It was his idea to steal your reindeer. No one else wanted to have anything to do with it.'

'Thank you for looking after my reindeer,' said Father Christmas kindly. 'I've got a very special Christmas present for you all.'

'What are you going to give them?' asked Simon.

'You'll see,' smiled Father Christmas, and he put his hand into his coat pocket and brought out a handful of shimmering powder. 'It's amazing what a little bit of Christmas stardust can do!'

He tipped it over the Big Top. Instantly, it was transformed from a sad, threadbare old tent into a sparkling place full of light and colour.

'Happy Christmas everyone!' called Father Christmas as they flew away.

'Thank you, thank you, Father Christmas,' called Wanda as everyone in the circus waved goodbye.

'I knew you were Father Christmas all the time,' said Simon.

'Did you?' said Father Christmas. 'But now we had better get you home.'

'And quickly,' said the sleigh. 'We're nearly out of time! The spell will soon be over.'

'Here's my house,' said Simon a little sadly. 'Goodbye.' And he gave Father Christmas a big hug. 'I won't forget you.'

'Er -well - I won't forget you either, Simon. Remember to hang up your stocking tonight, won't you?'

Late that night, Simon thought he heard just faintly on the roof the sound of hooves and a well remembered voice saying, 'That's Simon's present done. I'll miss him, I will. Come on! Up Dasher, up Dancer, up Comet, up Prancer! Up Donner and Blitzen, up Cupid and Vixen - and Rudolph. We don't want to lose any of you again, do we?'

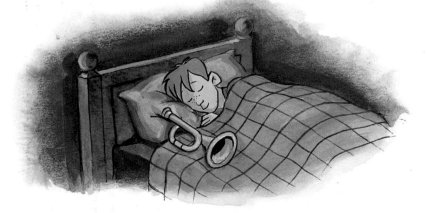